李峰畫集

A COLLECTION OF LI FENG'S PAINTINGS

沁德居藝廊
CHIN DER JYU GALLERY

2008

A COLLECTION OF LI FENG'S PAINTINGS

傳統仕女畫的風格發展

李 峰

我們今天通常將傳統國畫中女性題材的作品稱爲"仕女畫"，按照藝術分類學的規律，一個畫科的形成是其審美價值得到普遍認同的結果。在中國繪畫史上，從女性題材出現到仕女畫科的形成，乃至以後內容的拓展，涵義的演變，形式手段的更新，其間反映了不同時期人們對這類題材的審美認識的變化。

中國古代的繪畫，從先秦春秋戰國開始，逐漸擺脫了作爲一種工藝裝飾的附屬地位而走上獨立發展的道路，也就是這時，出現了最早獨立的仕女人物畫作品。出土于長沙陳家大山戰國楚墓的帛畫《人物龍鳳圖》，是現今所見最早的一幅獨立的仕女畫，描繪一位貴族女子祈禱升天的情景。衣著華麗，面容清秀，窈窕細腰。其身體的輪廓結構以墨線勾描，衣服、面部有彩色的平塗或點染。這一時期的青銅器、漆器裝飾繪畫中，也有對女性形象較完整的表現，技法與上述帛畫大致相類。

兩漢至魏晉南北朝，是傳統仕女畫的風格初步形成時期，這一時期發展了戰國以來人物表現以墨線勾勒與色彩暈染相結合的傳統方法，在人物造型、氣質的表現，構圖佈置以及意境的創造上都取得了一定進展。西漢以升天爲主題的長沙馬王堆帛畫中，以均勻流暢的線條勾描爲"骨"，施以明麗的色彩，刻劃出一位雍容華貴正欲走向天堂的貴婦形象。而洛陽八裏台西漢墓室壁畫中的女子，俊麗修長、髮髻峨峨，反映出漢代仕女人物畫創作的藝術水平。魏晉以後，仕女畫的風格開始體現出一種較鮮明的時代風尚，這種風尚首先在於人物的造型。我們可以來比較這一時期的一些作品：北魏司馬金龍墓木板漆畫、敦煌北朝壁畫、以及東晉顧愷之所作《洛神賦圖》，可以發現其中女性形象大致類似的造型特徵：人物一般直立而稍有動勢，面部多呈橢圓形，上身微前傾，下身借助衣紋隨風勢飄動而呈現動態，整個形象敦厚而不呆板、顯示出矜持、嫻靜的氣質。這一時期的作品中，筆線勾勒及色彩暈染更注重對動態、結構的準確表達，體現出畫家對人物形態的研究與理解。東晉傑出的畫家顧愷之，以其豐富的創作經驗，總結出人物畫構圖佈置，動態設計等技法原則，尤其是他總結出"傳神"的創作觀念，對此後仕女畫注重精神刻劃的傳統有著直接影響。顧愷之本人的仕女畫，用筆如春蠶吐絲一般緊勁連綿，鋪以淡雅的色彩暈染，輔敘出如春雲舒卷的衣紋結構。其畫風簡淡婉約，對人物內心世界的刻劃和意境的表現尤爲所長。如《女史箴圖》中塑的婦女形象，雲髻高聳，長裙曳地，衣帶迎風飄舉，儀容典雅肅慎，正是六朝女性美的典型。而另一幅作品《洛神賦圖》，則以婉轉纏綿的筆調描繪了驚豔絕倫的洛河之神和一個帶有夢幻色彩的愛情神話。

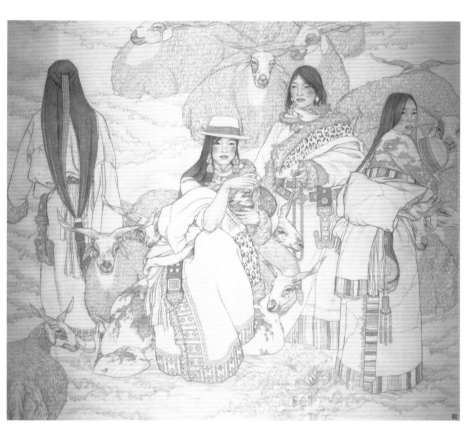

《心原》 ▎ Land in My Heart

177x163.3cm 素描 1994年

傳統仕女畫發展到唐代，開始走向風格的成熟與創作的繁盛階段，它的標誌應該是中唐朱景玄的《唐朝名畫錄》中第一次出現了仕女畫科的記載。這一時期，唐代上層社會奢侈華麗的風尚體現在仕女造型中往往以豐肌秀骨爲美，這種造型風格與六朝崇尚清秀矜持的美截然不同，人物體態豐滿健康，面部曲眉豐頰，配以貴質華類的衣衫和裝飾，盡顯熱情奔放婀娜多姿的時代氣息。現存西安地區唐陵墓室壁畫中的仕女形象，充分體現了這一風尚。唐代仕女人物的表現開始建立在寫實的要求之上，在六朝的線描基礎上創造了"鐵線描"、"遊絲描"、以及綜合這兩種描法的"琴弦描"等，衣紋勁簡磊落，色彩絢麗濃豔，張萱和周昉都是擅名一時的畫家，他們的作品真實地寫照當時貴族女子遊春、整妝、鼓琴、賞雪等幽靜閒散而奢侈的生活，描繪她們的精神世界。從流傳張萱的《搗練圖》周昉的《簪花仕女圖》等作品中，我們可以看到唐代畫家表現人物細部的能力：豐圓的面部，以朱色暈染耳根，眉和口的刻劃更細膩，口小而圓，眉幾乎都畫成蛾眉、八字眉，有的還在眉間點上"花子"。還用極細的線描表現服飾的光潔華美，用濃淡不同的墨色烘染服裝的質感和衣紋的翻疊轉折。唐人這種細膩的寫實技巧在五代仕女畫中得到繼承與發揚，不但結構的表現更具體實在，而且設色暈染的技法也更成熟。南唐畫院畫家顧閎中所作《韓熙載夜圖》，不但色調和諧統一，而且還以傢俱極深的用墨表現來襯出仕女衣飾的豔麗多姿。在筆線的表現上，則將唐代流利的線描加以頓挫，形成獨特的"戰筆描"，這種筆法剛柔相濟，表現力更強。此外五代仕女的臉型與唐代相比，則由豐圓變爲橢圓，下額變尖。總體看來，唐、五代時期的仕女畫，是在寫實的基礎上進行的，富有盛妝的風格。相比之下，唐代中期以前的作品多渲染一種歡愉的氣氛和顯赫的聲勢，而晚唐五代以後的作品更趨於沈靜內斂，多表現宮廷、閨閣婦女空虛、閑靜的內心世界。這一點，我們可以對比生活于盛唐的張萱和生活于中晚唐的周昉的作品，得到印證。

宋元時期是仕女畫由晉唐以來的古典風格向明清以後的近世風格轉變的過渡期，這一時期的作品，在題材內容、藝術表現上都有承前啟後的特點。宋代仕女畫的題材趨向故事化與生活世俗化，著重表現上下各階層女性的普遍美。一方面晉唐以來流行的歷史故事、貴族婦女題材仍然存在，如北宋《四美圖》，藝術表現基本承襲前代的傳統。另一方面帶有風俗色彩的女性生活題材，如李嵩《貨郎圖》中被孩童促擁的母親，以及王居正《紡車圖》中的勞動女子，畫家用現實主義的手法表現她們安靜、祥和的美，反映世俗生活的種種情態。宋代仕女造型一般俊俏秀麗，突出窈窕修長的體態，結構嚴謹準確。在技法上白描畫的成熟及鐵線描、蘭葉描、釘頭鼠尾描等多種描法的運用，使仕女畫表現開始突破漢唐以來單一的工筆設色畫法，而創造出更多的技法形式。白描是一種著重以墨線的濃淡粗細、轉折變化來概括形體的畫法，有時也施以淡色或淡墨暈染。宋代白描仕女衣紋組織嚴謹緊湊，挺拔流暢，疏密相間成韻，氣貫整體。武宗元為道教壁畫《朝元仙仗圖》所作的粉本小樣已初具這一特徵。而將這一藝術形式推向成熟的則是李公麟，他創作的白描仕女形象，如《維摩詰圖》中的天女像，以頓挫變化的線描，表現出人物風骨特立的氣質，不施丹青而光彩動人。及至元代王振鵬、張渥都直接師法李公麟，張渥創作的《九歌圖》中湘君、湘夫人，線條錯落有致，簡潔清逸，為元代白描仕女畫的代表。此外，衛九鼎所作白描《洛神圖》，人物單純靜美，畫風溫和清膩，體現了元代文人繪畫講求"士氣"的風尚。元代工筆重彩仕女的高度成就以民間畫工繪製的永樂宮道教壁畫的眾多女仙像為代表。其線描簡潔準確，色彩華麗而富於裝飾性，人物的形象豐滿健康，氣質溫和寧靜，有些細部的表現採用堆金瀝粉來突出衣袖、纓絡和花鈿，繼承了唐代的"盛裝"裝飾風格。

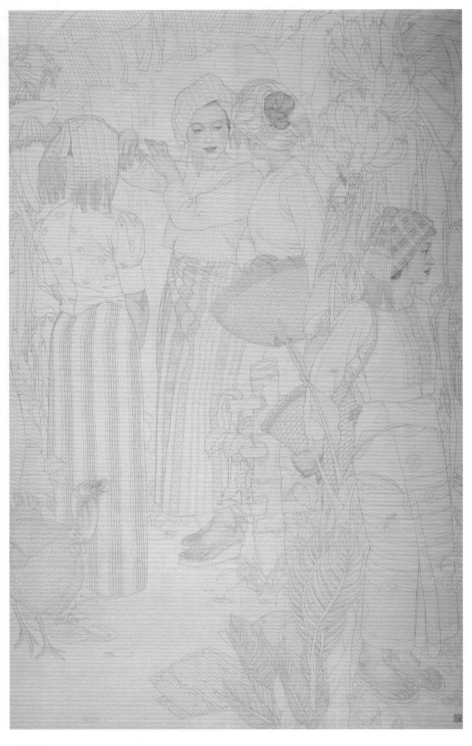

《南風》 **South Wind**

227.7x140.2cm 混合媒材 1999年

宋元以後，由於山水題材在繪畫中佔據主導地位，人物故事畫呈相對衰弱的狀況，但是在仕女畫創作中仍湧現出一些好手，他們吸收前人的技法形式，並且進行融合創新，明代仕女畫發展中出現的各種形式風格就反映了這一點。仇英、唐寅等人的工筆仕女畫沿承唐以來的傳統；而吳偉則擅長以水墨表現寫意的仕女畫，這種揮灑自如，筆墨酣暢的風格在明代仕女畫中占重要的地位。此外，白描畫風則被晚明陳洪綬、崔子忠推向極致。經歷了一段時間的積累以後，仕女畫在晚明至清代又迎來了新的創作繁榮的局面。明代仕女畫的人物造型一般沿承宋元以來的風尚，但面容更偏於清瘦，但晚明則出現了以陳洪綬為代表的變形風格。他所畫仕女形象在古拙中透著俊美，面容多廣目方頤，衣紋結構奇特誇張，補景的樹石亦詭譎離奇，其中蘊含著孤傲倔強的性格識見，又不失女性形象的嫵媚與溫柔。陳氏仕女畫的筆法風格一般有兩種，一則方折有力而略具粗壯，一則清圓細勁凝煉沈著，設色均以清淡為主。這一時期晚明仕女畫的獨特風格對後世仕女畫創作有著深遠影響。入清以後，由於社會的需求，仕女畫創作空前活躍，余集、董琪、改琦、費丹旭等人都是專門創作仕女畫的高手。由於柔和秀逸的審美觀的影響，他們的作品體現出共同出現的清雅細膩的風尚。畫中仕女往往被誇張為纖弱的體態，削肩、尖臉、柳腰，並以梧桐、柳樹、荷花等補景來襯托一種優雅的意境，有時還將詩詞直接題在畫面上，技巧也崇尚細巧秀逸，筆墨疏秀輕靈，設色淺淡明快，構圖簡練，將女性或嫻靜、或妍雅、或香豔的各種儀態表現得淋漓盡致。他們的作品雖然有著廣泛影響，但也暴露出公式化和病態美的缺點。當然在這種主導風尚之外，也有另一些畫法，如清代中期宮廷中的仕女畫受西畫影響，開始在面部採用明暗暈染法，補景則運用焦點透視的畫法，具有中西融合的風格--這種風格其後在二十世紀中後期成為現代仕女畫的一個重要形式特徵。而清末"海上三任"的仕女畫創作中，發揚了晚明古拙俊逸的變形風格，在準確造型的同時，又在筆法中揉入書法的韻味，生動地刻畫出人物的個性。

從歷史變遷的漫漫長河裏，我們可以看到，傳統仕女畫在其自身形成和發展的過程中，湧現出眾多擅名一時的畫家，產生了風格迥異的各種流派，形成了東方繪畫特有的藝術景觀。她以一種獨具民族特點的藝術形式，展現了東方人對女性美的認識與體驗過程。直到今天，大量流傳下來的繪畫珍品還深深地影響著我們的藝術創作。

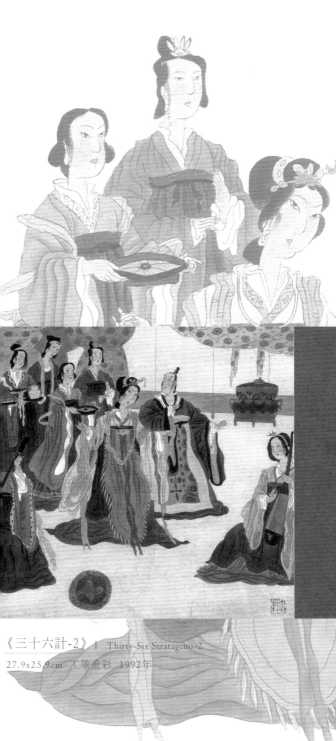

《三十六計-2》　Thirty-Six Stratagems-2
27.9x25.9cm　工筆重彩　1992年

The Stylistic Development of Traditional Beautiful Women Portraits

Li Feng

What we today usually call traditional Chinese Painting of female subjects, the "Beautiful Woman Portrait," follows the regulations for various categories. The painting subject formation is the result of the aesthetic value that has obtained general recognition. In the history of Chinese painting the painting style for females appeared and then expanded its content in later periods. The meaning changed in evolution and the formalistic method was updated; it reflected the changes from each of the different eras, and the people's aesthetic understanding for this kind of theme.

Chinese ancient painting started in the early Qin period and continued through the Spring and Autumn period, and the Epoch of Warring States; it gradually broke away from decorative art techniques to gain its own unique position on the road to independence. The most independent beautiful women portrait work appeared at this time. The silk fabric painting style of "The Dragon and Phoenix Portrait" was unearthed in the Zhu Tomb Charng-Sha Chen-Jia Ta-Shan of the Warring States. It is the oldest example of the painting style of the independent female portrait that we have discovered so far; it portrays a noble woman praying to rise to heaven. The luxurious cloth and well-shaped face, and the attractive, charming, slim waist use the ink line to form the body's outline structure while the cloth and face have applied paint colors and dyed dots; in the decorative painting on the bronze instruments and the lacquer ware of this period the female image also appears more complete. In general, the techniques are similar to the female image in the silk fabric paintings.

The two Han-Dynasties and the Wei Jin South and North Dynasties were the era where the traditional beautiful women portrait style primarily took shape. After the Warring States this period developed the portraits that appear in the traditional method and have a mutual connection with ink line strokes and giddy colors; the style and temperamental appearance of the portrait had a structure, layout, and creative mood that indicated definite progress. In the West Han Dynasty, the major theme was that of rising to heaven; in the silk fabric painting in the Charng-Sha Ma Wong Tomb, uses a smooth even line to strike the "bone" structure and apply the clear color to describe the image that a graceful and poised noble woman intending to walk up to heaven. The women in the wall painting of the LoYang Bai Li Tai West Han Dynasty Tomb appear talented, superior, and slender with their hair tied in a knot with solemn gravity; they reflect the creative horizontal art of the Han Dynasty's beautiful women portraits.

After the Wei-Jin Dynasties, the style of beautiful women portraits took a more definite and clear shape in a timely, progressive fashion. This development began the form of the portrait. We can see this as we compare some works of this period: namely the wooden lacquer paintings of the Shi-Ma Jinglong Tomb in the North Wei Dynasty, the wall paintings at Duen Huang of the North Dynasty, and the work "Ode to the Goddess of the Lo River" Painting by Ku Kai-jih of the East Jin Dynasty. We discover the style and characteristics of the female image were similar in general: the portrait figures are standing and have little moving gestures; the faces appear oval and the upper body leans a slight forward while the lower body presents movement; the slightly blowing wind moves the cloth fabric texture, the whole image is sincere but not monotonous; it shows how one conducts oneself with circumspection and with a quiet and refined temperament. The works of this period have lines strokes and dizzy color dyes and are more concerned with the performance of accurate movement and structure and to show the study and comprehension of the portrait form by the painter. The outstanding painter, Ku Kai-jih of the East Jin Dynasty, who had a very rich creative experience, had established the structural layout of the portrait and movement design etc. His technique principles especially established the creative concept of "a vivid portrayal." This had a direct influence on the later beautiful women portrait paintings, which focused more on a spiritual description.

The beautiful women portrait painting of Ku Kai-jih, used the brush like a spring silk worm that spit out the silk fiber in a tight uninterrupted application with a light elegant color dye; he also portrays a loose, curly spring cloud pattern in the cloth fabric texture structure. His painting style appears simple, light, and elegant, and specializes in the description of the inner heart's world and mood impressions. The lady's image in the "Female Etiquette Officer Painting" shows lady's hair coiled up high, the long skirt drags on the earth and the cloth band blows up with the wind; the looks are one of elegant and cautious reserve. This is the typical female beauty in the Six Dynasties. And another, the "Ode to the Goddess of the Lo River Painting," has the tone of a persuasive and exceedingly sentimental description of the amazing and extremely stunning beautiful Goddess of Lo River and the love myth with colors of reverie.

The traditional beautiful women portrait painting developed further in the Tang Dynasty, and became a more mature style in this booming period of creation; its symbol became the first beautiful women portrait painting documentary in the "Dynasty's Famous Painting Collection" by Zhu Jing-Xuan (Middle Tang). During this period, the upper class society pursued an indulgent, luxurious and expensive hab life style. This showed in the beautiful women's form and often focused on the plump fleshy fine bone structure as a symbol of beauty; this was an absolutely different style from the Six Dynasties that had advocated the pure and elegant, where one conducted oneself with dignity and reserve. The portrait gestures are very full and voluptuously healthy; the face had a plump chin and curved eyebrows and the ladies were dressed in an expensive quality luxurious style cloth with decorative ornaments. This completely showed the passionate free flow of a very pretty well-poised time and atmosphere. It still exists today in the beautiful women images in the Tang Tomb wall paintings near Xian; these represent the fashion trend of this period. The beautiful women portrayed in the Tang Dynasty started to establish realistic requests; the foundation for line and description in the Six Dynasties created an "iron line drawing," a "wandering fiber drawing" and the "strings of musical instruments drawing," which combined these two methods. Examples are the strong cloth texture and the simple, free and easy, bright colored magnificence of Zhang Xuan and Zhou Fang. Both were well-known painters at that time; their works truly described noble women on a spring outing, adjusting make up, strumming musical instruments, enjoying snow scenes and the tranquil leisurely walks of a luxurious life; these all described their spiritual world at that time. From the transmitted works of "Practice Pounding Painting" by Zhang Xuan and "Lady Wearing a Flower Portrait" by Zhou Fang, we can see the ability of the portrait details of the painters of the Tang Dynasty, the plump round face and the application of the orange red color dye to the ears; the description of the eyebrows and mouth were getting more fine. The mouth is small and round and the eyebrows are almost painted as moth shape or shaped like the Chinese character for 8; sometimes the "flower seed" was added between the eyebrows.

Using extremely fine drawn lines can portray a clear clean luxurious beautiful cloth, and using different heavy and light ink colors to dye the cloth texture provides the turned overlapped fold of cloth texture; the Tang Dynasty painters had this kind of fine realistic technique. They maintained the skill from the Five Dynasties Beautiful Woman Portrait Painting and developed it further to enhance their structural performance that was more concrete and solid; their techniques of designed color and color dye were more mature. In the "Han Si Tzay Evening Party Paintings" by Ku Hong-zhong of the South Tang Painting College, the color tone appears not only harmoniously unified but also uses the dark ink colored furniture to provide contrast to the radiant, captivating look of the lady's cloth decoration. The brush line performance has smooth line drawing and adds to its turn backs and becomes the unique "war of the brush line." This brush stroke took both soft and rough turns and has a stronger performance power. Besides, by comparing the ladies faces between the Five Dynasties and the Tang Dynasty, they change from plump to oval, the lower forehead becomes sharper. Generally speaking, in the Tang and Five Dynasties period they came from a realistic foundation and a style in full dress. Using this comparison, the works before the middle Tang had more play up with color and a joyful atmosphere and illustrious prestige and power; and the works after the later Tang to the Five Dynasties period tend to more quiet with an inner preserve and mainly express the loneliness of the women in the palace and in the women's quarters; they describe the quiet world of their inner heart. On this aspect, we can see that the contrasting life between the booming Tang period by Zhang-Wuan and later Tang's life by Zhou Fang's works prove the point.

The Sung/Yuan Dynasties are a period of transition for the beautiful women portrait painting, and a change from Jin/Tang Dynasty classical style to the Ming/Qing's modern style. This period's works had a material content, and the art performance had the characteristics of maintaining the tradition and continuing a further style. The subject matter of the Sung Dynasty's beautiful women portrait tended to be story telling and to describe life's common practices and focused on the different individual upper/lower class of the average female's common beauty. One side of the popular historical stories, the noble female material still existed since the Jin-Tang. Take for example the "Four Beauties Paintings" of the Northern Sung, its artistic performance was basically one of maintaining the previous Dynasty's tradition. Its other side portrayed the customers' colorful female life experiences. For example, a mother is surrounded with children on the "Peddler's Painting" by Lee Sung, and there are working women on the "Spinning Wheel Painting" by Wong Jyu-cheng; the painter uses a realistic method to express their quiet and auspicious beauty, and reflects the common social conventions of life's various situations. The form of the female portraits of the Sung are overall good looking with smart, elegant charming slender body gestures with an accurate cautious structure. The mature technique of outline drawing and the iron line drawing, the orchid leave drawing, the needle head rat tail drawing etc show multiple drawing methods were exercised. This made the female portrait performance start to break from the single fine stroke design and color painting method of the Han/Tang and create a more technical form. Outline drawing is a painting method, it is more concerned with the ink line, thick, light, raw ,fine and a turning point change that includes the body shape; sometimes it applies a light color or light ink to the dizzying dye color. The Sung's outline drawing expressed the women's clothing lines with a very cautious tight tempo arrangement; the smooth straight lines, tightened/loose take turns creating the mood with each other, and fill the whole with a spirit. In the Daoist wall painting "Zhao Yuen Goddess Scepter Painting," by Wu Zhong-yuan, a small traced sample primarily displays this characteristic.

Another person who pushed this further to a mature stage of art form was Lee Kong-ling; his creation of the outline drawing for the female image such as the Heavenly Goddess image in "Wei Mou Jeh Painting" faced a setback with various stroke line drawing, and presented the portrait with a unique outstanding characteristic and temperament but did not put the color but brilliance. Up to the Yuan Dynasty Wong Zhen-pong, Zhang Woh directly learned from Lee Kong-ling, Zhang Woh's creation "Jeou Ke Painting," with the characters Ms. Shiang Jiun & Mrs. Shiang, the management of the disorderly and orderly lines is simple, clean, clear, perspicuous, and free. It represents the outline drawing women's portrait. Next to the outline drawing, the "Goddess of the Lo River Painting" by Wei Jiou-ding, is a simple quiet beautiful portrait; the mild, clean, plump and soft style has shown us how the scholarly painting of the Yuan Dynasty emphasized the fashion of being "rustic." The delicate drawing with heavy color of the Yuan Dynasty's beautiful women portraits highly achieved this. The Yong Le Palace Daoist wall painting's numerous goddess images are representative; they were painted by the painters of the non-government sector. With their accurate clean-cut line drawing and the luxurious full color of ornamentation, the portrait's image portrays a very full and voluptuously healthy mild, quiet temperament. Some details expressed use piles of gold and asphalt powder to make the cloth sleeves stand out, the ornamental fringes on the garment and the flower filigree maintain the "rich attire" dress styles of the Tang Dynasty.

After the Sung/Yuan Dynasties, because the mountain/water landscape subject occupied the leading position in painting, the portrait stories appeared relatively weak in this situation. But in the beautiful women portrait style, many good painters still came forth; they absorbed the technical form from previous painters, and proceeded to mix it with the new creations. In the development of the Ming Dynasty women's portrait painting there appeared diverse individual forms and styles that reflected this point. Chyou Ing and Tang Yean etc. with their delicate stroke painting had maintained the tradition since the Tang. Wu Wei specialized in ink abstracts for women portrait painting; this kind of painting worked freely and with a brushed ink smooth style in the Ming Dynasty had a very important position. Besides, the outline drawing was highly recommended by Chen Hong-shou and Cui Tzyy-zhong of the later Ming Dynasty. Through the accumulative experience of this period, from the later Ming to the Qing, women's portrait painting faced a new creative booming status. In women's portraits of the Ming Dynasty, the portrait form had continued the fashion from the Sung/Yuan; the face appeared cleaner and slimmer, and the later Ming changed to this exaggerated style, Chen Hong-shou is the representative of this; his women's images were gorgeous with ancient awkwardness, the face had wide eyes and square cheeks, the cloth line structures were extremely exaggerative and the background trees and stones were also strangely intriguing. They expressed the proud and aloof, intransigent characteristics and viewpoint. But the female's images are tender soft and charming. Chen's women portrait brush style in general had two approaches, one was a square fold with powerful and rough strength, the other one was a clean, round, fine, tough concise calm and steadiness, and the color application mainly used clear light colors. This unique style of women's portraits of the late Ming period had a very deep and far influence on future portrait painting creations.

After the Qing Dynasty, because of the demands from society, the women's portrait creations became more active than ever; Yu Jyi, Dong Chi, Gai-Chi, and Fai Dan-Xu etc were the master painters; all specialized in women's portrait painting creations. With the influence of the aesthetic view of a soft tender free elegance, their works showed mutual clean elegant delicate trends. The female in the paintings was often exaggerated as having fragile weak body gestures, cut shoulders, a sharp face, and a willow waist; the wu-tong tree, the willow tree and lotus flowers served as background to provide a contrast to the elegant mood; sometimes the painters would even put poems directly on the painting; this technique trend upheld a delicate clever and freely charming brush ink with loose, nimble color application and a clear light quick refined structure that showed completely the various females as quiet, refined, seductive and charming with glamorous body gestures. Although their works were widely influential, they exposed the stereotypical state of the disadvantage of beauty. Naturally besides this main leading fashion, there were other kinds of painting techniques, like the middle Qing Dynasty women's portraits in the palace which were influenced by western painting, and started out using the face's bright/dark dye method; the background uses a focal point and perspective in drawing; these mixed the Chinese/Western styles-this practice became an important form characteristic for the modern women's portraits after the middle of the 20th century. The creation of the women's portrait in the "3 Ren Brothers Ocean Style" in the later period of the Qing Dynasty glorified the ancient awkward, gorgeous freedom changing style of the later Ming period. At the same time, the exact stylistic form also blended the drawing with calligraphy's charm, and vividly portrayed the characteristics of the gesture.

From this extended historical evolution's long river, we can see how the style with its formation and developmental process in traditional beautiful women's portraits developed; many famous painters had emerged and created many entirely different styles and schools; these became the unique oriental paintings heritage; these treasured paintings have been massively transmitted up to today and still deeply influence our artistic creations.

意象造型和高雅畫境　李峰的工筆重彩畫

邵大箴

李峰從80年代中期開始進入畫壇，從事工筆重彩的人物畫創作，一直以探索者的姿態，邁著穩健的步伐，在踏踏實實地解決他面臨的課題。他不斷有新作問世，作品也得到同行與廣大觀眾的好評，多次在大展中獲得榮譽與獎勵。作為中年畫家的他，能躋身於當代著名工筆重彩畫家之列，不能不說這與他的勤奮好學、善於思考和勇於實踐有密切的關係。

工筆重彩在我國有深厚的傳統，但如何認識這種傳統藝術的價值，在美術界則經過一段曲折的歷程。從前衛的立場予以否定自不用說，從文人水墨畫的角度來詰難工筆重彩，也給從事這門藝術創作的人以不小的壓力。值得我們高興和驕傲的是，近20年來一群有志於發揚傳統工筆重彩的中青年畫家，充分認識到自己身上肩負的重任，通過自己的艱苦探索，終於打開了嶄新的局面，給這個傳統藝術門類帶來了勃勃生機。李峰就是其中的一位。

工筆重彩要在新的歷史時期重振雄風，必須適應新時代人們的審美需求，必須解決它面臨的一系列課題：如何面向現實生活，塑造新的藝術形象，反映時代的風采；在藝術技巧上，如何吸收外來營養，豐富傳統工筆重彩的藝術表現力；當然，最重要的是要解決如何在新的創造中保持傳統美學的品格的問題。讀李峰的畫，我覺得他一直在自覺地思考和處理這些問題，在實踐中不斷積累經驗，藝術技巧不斷提高，創造膽識也不斷增強。

李峰是一位關注現實生活的藝術家，他懂得生活體驗對藝術創作的重要性，他很注意從社會生活和自然生活中吸收養料。他的作品以自己的生活經驗為基礎，寫自己的切身感受，所以很有藝術感染力。例如他創作《心原》，是從在甘南藏族地區體驗生活時所獲得的靈感，那裏遼闊、空曠的自然景色，那裏遺留下來的古戰場殘跡，那裏藏族婦女的遊牧生活……這些印象交織在一起，使他產生創作這幅畫的激情。他以牧民婦女、羊群和草原為基本形象因素，以廣闊的大自然為背景，表現藏族牧區勞動婦女生活的寧靜與安適。同樣《遠芳》、《家》、《香蕉園》、《南風》等，他都是從現實生活中提煉的素材，都以自己的切身感受為創作的動力，所以這些作品中的形象不落俗套，頗有生活氣息。

融合中西是李峰藝術創作的一大優勢，由於他對工筆重彩傳統有過系統的學習和研究，也由於他有很好的寫實造型功力，更重要的是他有現代的創造意識，他的工筆重彩畫具有不同於傳統工筆重彩的新面貌。他善於把西畫的寫實造型納入傳統工筆重彩的表現系統，善於把外來的因素為我所用，將其有機地融入適合於中國人審美的創造之中。他懂得，素描造型雖與工筆重彩的工整描繪不屬同一藝術體系，但是它塑造物象形體的技巧可以用來充實工筆重彩的表現手法。此外，在質材的使用和形體質量感以及畫面的處理上，日本畫也提供了可資借鑒的經驗。可貴的是，李峰在吸收外來藝術營養的同時，始終堅持民族傳統的審美觀和創造意識，在"意象造型"和"畫境"上下功夫，由此形成他自己的繪畫風格。所謂"意象造型"，就是說他筆下的人物形象是寫實的，但不是純客觀的描寫，而是"以意取象"，是"以描繪者所要表現的主觀精神的需要來規定藝術形象與客觀物象形貌之間'形似'程度的一種造型方式，換句話說，即是以己之意,塑彼之象,傳己之情。"（見李峰：《關於"意象造型"》，載《美術界》，2002年，第7期）李峰重視形而又不拘於形，在形似中更關注確立自己的態度，表達自己的主觀意念和感情。他以自己的審美理想和情趣來駕馭造型，來處理人物形象和處理畫面。所謂"畫境"，就是繪畫創造所要追求的一種境界。李峰根據工筆重彩這門藝術的特點和他自己的個性，在創作中追求一種寧靜、安適的境界。他塑造的藝術形象有相當的理想化成分，但是從現實中來，不失現實感；他的不少作品如《家-傣族系列作品》，屬於"現代仕女畫"，人物形象端莊、優美，格調甜而不媚。為營造這種境界和氣氛，他採用了古代傳統壁畫中的構成因素，有意識地壓縮畫面的三度空間，以加強平面的視覺張力；同時採用優雅明快的色彩，輔以較強的黑白構成對比；由於塊面分割與線形處理舒暢、簡潔和線條沈穩、凝重，使畫面的大效果在優美、明朗中不失厚實感。

工筆重彩畫的創作因為工序繁複，易沾染匠氣；而仕女畫，則常常因描繪女性優美分寸掌握不好而失之於豔俗。李峰之所以能遊刃有餘地處理工筆重彩藝術中一系列複雜問題，能使自己的作品具有高雅的格調，主要得益於他的藝術修養。他除了刻苦勤奮、積累了豐富的實踐經驗外，還很重視研究理論和思考問題。他撰寫了不少有學術見解的文章，結合工筆重彩畫的現狀探討繪畫創造規律和原理，諸如在如何適應現代人的審美需求進一步發揚工筆重彩傳統以推進這門藝術的革新，以及在繪畫面臨"新藝術"挑戰的情況應如何對策等問題。他還編著了不少有新意的藝術技法教材，如《現代工筆人物表現技法》、《中國畫仕女畫法》等。這些著述說明，李峰不僅是一位有成就的實踐家，而且還是一位視野開闊、學養全面、有獨立見解藝術家。

李峰還很年輕，在他前面的藝術路程還很長，我們期待他在藝術上取得更豐碩的成果。

Image Modeling and Elegant Artistic Conception

Remarks on Mr. Li Feng's Works of Meticulous Rich Coloring

Shao Dazhen

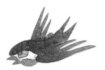

Mr. Li Feng started his artistic career in mid-1980's, and has been dedicated to the portrait painting of meticulous rich coloring. And ever since then, he has been making steady advances in his artistic exploration through his research projects in a down to earth way. He is really a prolific author whose works enjoy favorable comments from a large audience and have won many honors and awards in quite a few important arts exhibitions. As a middle-aged artist, he has already ranked among those well-known contemporary artists specializing in meticulous rich coloring and all this can undoubtedly be attributed to his unfailing diligence, intelligent thinking and courageous practice.

Meticulous rich coloring as an art form is profoundly rooted in Chinese traditional painting. However, an unprejudiced recognition of the value of this traditional art has gone through a rather winding path with many twists and turns. In addition to the negative comments from the standpoint of avant-garde schools, heckling criticisms with the viewpoints of those literati who favor wash painting also impose considerable pressure upon those who are engaged in the creative work of this genre of art. Yet, during the recent two decades, a team of young and middle-aged artists with a devotion to carry forward this traditional art have kept working and exploring through their painstaking efforts along an arduous path, and have so far made tremendous progress and have brought this genre of art to a brand new and distinct stage of development, thus instilling in this artistic genre fresh vigor and vitality. And Mr. Li Feng is a prominent representative among them.

In order to re-establish its prestige at this new historic moment, it is absolutely necessary for artists engaged in meticulous rich coloring to have their works adapted to the aesthetics and taste of the contemporaries, to carry out a whole string of research projects such as how to reflect the real life in modern society, how to create new artistic images and embody the mores and mien of the new era, and how to make the best use of foreign pabulum in techniques so as to enrich the artistic expressive force of the traditional meticulous rich coloring.

It goes without saying that the most important is to solve the problem of keeping the character and style of the traditional aesthetics in the process of new invention and innovation. However, while I appreciate his works, I have found Mr. Li Feng is giving a conscientious meditation to, and an ingenious treatment of, these issues, thus accumulating experiences in his assiduous efforts, improving artistic techniques and reinforcing the creative power, courage and insight.

As an artist, Mr. Li Feng attaches great importance to social reality and fully understands the significance of real life experience to artistic creation and carefully absorbs nutrition from social life and Mother Nature. His works are mainly based upon his own life experience involving his keen observations and feelings, hence artistically impressive. For instance, "Grassland in My Heart" gains the inspiration from his personal experience in Tibetan Autonomous Prefecture in Southern Gansu, Tibet where the vast stretch of open land that offers a magnificent natural scenery, the ruins of the ancient battlefields, the nomadic life of the Tibetan women are intermingled to kindle his creative passion for this painting. Taking nomadic women, sheep flock and the vast stretch of pasture as the fundamental components and the great natural environment as the background, he vividly depicts the tranquil and cosy life of the laboring women in the Tibetan pasturing areas. And likewise, other works such as "Grassland in the distance", "Home", "Banana orchard", "The Southern Wind" and so on all gained the materials distilled from real life, having his personal recept as his creative momentum. The images in these artistic works are new and filled with tang of real life and they are distinctly different from conventional patterns.

One advantage in Mr. Li Feng's artistic creation is his ingenious combination of Chinese and Western styles in presenting arts. Since he has made a systematic study and research in Chinese traditional style of meticulous rich coloring, and he has a solid foundation in true-life portraying, and most of all deep down he possesses a modernistic consciousness for realistic creation, and his works take on a new look tinged with fresh flavor different from the conventional meticulous rich coloring. Besides, he is good at adapting the western true-life portraying into the system of presentation in traditional Chinese meticulous rich coloring, dexterous in turning foreign and exotic ingredients to serve his own purpose and organically puts them into his creation that coincides with the aesthetic appreciation of the contemporaries in China.

He is fully aware that pencil sketch does not belong to the same artistic system with meticulous rich coloring, yet the techniques for shaping the subjects in painting can be used to enrich the expression in meticulous rich coloring. In addition, in such aspects as the use of materials, the impression of the quality of the depicted objects as well as the general treatment of the representation, there are valuable elements and experience that can be drawn from Japanese painting.

What deserves admiration and esteem is his adherence to the national and traditional aesthetic views and creative conscientiousness, with which he has made great efforts in image modeling and elegant artistic conception, hence his own distinctive painting style.

By image modeling, it is meant that the figures he paints are true to life, but they are not sheer objective delineation but rather an attributed image by the artist, in which "the modeling is achieved through the subjective spiritual needs of the artist thus deciding the degree of similarity in shape between the artistic image and the objective person, and this way of creation is, in other words, to create the image according to the artists' idea and instill in it his own affections" (see Li Feng: On Image Modeling carried in "the World of Fine Arts," 7th issue, 2002) .

In his creative work, Mr. Li Feng pays due attention to the form yet he is not confined to the outer similarity, but rather he aims at establishing his own attitude and stance through a similarity, thus expressing his own subjective will and spirits. With his own aesthetic ideals, interest and taste, he carefully handles his modeling and the treatment of the characters and the general process of the depiction.

By Artistic Conception, it is meant the goal of pursuit in artistic painting creation. According to the characteristics of this meticulous rich coloring and his own personality and disposition, Mr. Li Feng pursues an ambience of ease and tranquility in his artistic works. There are considerable idealized elements in his shaping of the artistic images that come from reality with a fully real and solid presentation. Many of his works belong to the genre called "Modern Beauties," such as "Homes - a series works of Dai Ethnic Groups," and in these works the characters are presented as elegant and dignified, lovely and sweet with no trace of coquetry. In order to create such an atmosphere and taste, Mr. Li Feng has adopted some of the components found in ancient traditional Chinese frescos, and consciously compresses the three-dimensional space, so as to reinforce the tensility on the plane picture. And at the same time, very exquisite and bright colors are employed, associated with a rather strong contrast of black and white composition. And with a fluent and terse treatment of linear shapes and chunking, a stately and steady use of lines, he achieves an effect of lucidity and concinnity with no loss of massiness and solidity.

Because of the complicated working procedures, the creative work of paining of meticulous rich coloring is easily affected with stilted artisanship; and as for the genre of "Modern Beauties," it is easy for painters to fall to raffishness due to a failure of a proper measuring of the subtle taste and types and degree of beauty in portraying the female figures.

Mr. Li Feng, however, is able to deal with the whole series of complex and intricate problems in meticulous painting with rich coloring, and all the while he is able to maintain elegant taste and style with great ease, and all this comes mainly from his artistic attainments. In addition to his industry and the abundant experience of practice, Mr. Li Feng also attaches great importance to theoretical research and rational meditation of problems. He has written many articles with profound academic insight, discussing the present status of the meticulous painting with rich coloring and exploring the governing factors and principles in creative painting, such as issues on the renovation of this traditional art by adapting the works to the aesthetic demands of modern people so as to carry forward this genre of art, and the coping strategies when this conventional style of painting is challenged by various "new arts."

He has also compiled quite a few innovative teaching materials and monographs on techniques of fine arts, such as "Expressive Techniques in Meticulous Rich Coloring at the Modern Times," "Brushwork for Beauties in Chinese Traditional Painting," "Principles in the Composition of Chinese Painting of Traditional Style," just to list a few. All these works form a strong indication that Mr. Li Feng is not only a practitioner of great achievements, but also a truly gifted artist of independent thinking and broad vision as well as comprehensive culture and learning.

Mr. Li Feng is still young, and there is still a long way in his academic pursuit in art, and we are confident that he will show greater achievements in the years to come.

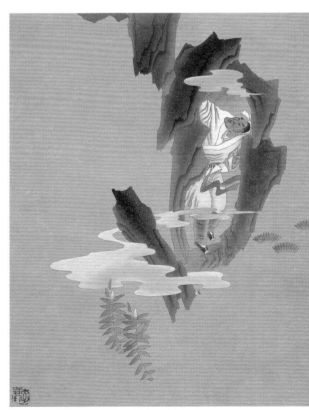

《桃花源記-2》 | Peach Flower Spring Diary 2
30.9x25.7cm 工筆重彩 1989年

現代仕女畫的文化意蘊

感受李峰女性形象的審美創造 夏碩琦

青年工筆畫家李峰，以扎實的藝術功力，優雅明麗的藝術風格，以及他所創造的一系列現代女性形象中所蘊涵的審美情調、文化意蘊，正越來越引起人們的審美關注。

李峰是一位"文武雙全"的畫家。他在大學專業藝術教育之餘，一方面開展現代工筆畫的理論研究，另一方面又在不間斷地從事著工筆畫的創作。他左右開弓，開拓、探索、前進。李峰的理論思考和研究是緊密的結合著創作實踐活動的、是從創作實踐出發的，又是爲解決創作實踐中出現的問題而有的放矢的。因而，他的理論決不雲山霧罩，決不在概念上兜圈子，有著鮮明的實踐性的特點。他的理論視野又是相當宏觀的，既有對文化史、美術史的審視與反思，又有對美學與創作普遍規律性問題的考量與把握。他的見解獨立、觀點鮮明，既不屈從於歷史成見，又不隨意附和流行潮流。他的理論思考、主張，往往可以在他的藝術探索和創作實踐中得到體現、印證。這種理論和創作實踐相統一的品格，難能可貴。從李峰一系列工筆畫的論文，和他一系列工筆畫的創作，可以分明地看出：他的創作實踐活動有力地推動著其理論探求的深入，他的理論研究又促進著他創作探索的突破。創作和理論的互動，使李峰在兩大領域都獲得了豐收的成果。

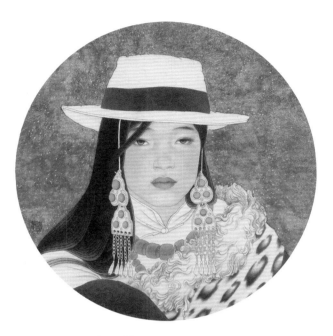

《心原》 ▎ Land in My Heart
直徑38.5cm 工筆重彩 2004年

在我國美術史上，無論古今，都有畫家、理論家兼具一身的範例。而且，往往是這些"雙翼齊飛"的畫家，率先提出了帶有原創性、本體性意義的繪畫理論或主張。晉顧愷之提出"傳神"論，南齊謝赫提出"氣韻生動"論，唐代張璪提出"外師造化，中得心源"論，現代齊白石又提出"似與不似之間"的創作主張；五代荊浩的《筆法記》，宋代郭熙的《林泉高致》，清代石濤的《石濤話語錄》等，這些畫家的理論、論著不但影響了我國繪畫史的走向，而且也影響了我國繪畫的形態和風貌。實踐出真知，這是放之四海而皆準的真理。在歷史大轉折時期的當代，各種理論、美學見解紛爭不已，在百家爭鳴、學術發展、文化振興的重要關捩點上，尤其應當重視創作家的參與。李峰的理論思考不僅僅在於其理論自身，而更在於創作家出席、參與理論探討的意義。

在歷史轉型時期關於工筆畫的爭論頗多，對於現代工筆畫的批評也不絕於耳。有站在民族文化立場的批評：指責有些工筆畫"太像西畫"，"太像日本畫"，疏離了民族傳統。相反，也有來自文化創新視角的批評：詬病某些工筆畫"太傳統"、"太程式化"，缺乏現代意識，游離於時代。還有來自文人畫視野的看法：水墨最爲上，寫意才是民族繪畫的最高水準。工筆畫"匠氣"、"製作"。工筆畫創作真難拿捏，似乎進退維谷。

惟其見解不一，各種觀點相殊，才學術思想活躍，百家爭鳴。惟其不同學術思想的相互抵牾，才推動了創作上的流派紛呈，形成現代工筆畫千岩競秀，萬壑爭流的局面。李峰從中國工筆人物畫的發展史、從中國畫形神關係的理論與西方寫實繪畫觀念的引進，以及從仕女畫的演變與社會文化心理的關係等角度，探討、研究了工筆人物畫、特別是現代仕女畫創作的本體性問題。很有自家的見地。

李峰認爲，中國繪畫在創作方法上存在著兩派："形似派"和"遺其形似派"。前者主張"以形寫神"，以"形似"來傳"物象之神"，追求"形神兼備"的藝術境界；後者主張"遺其形似"，"借物抒情"，追求"潛移造化而與天遊"的精神。他指出："從'形似'到'不似之似'，從表現屬於客觀物象的'神'到表現屬於描繪者自身的'神'，是一個審美觀念上的進步，但這並不等於後者可以代替前者，在中國畫發展道路上它們都閃現著

《清露》 ▎ Pure Morning Dew
直徑25.6cm 工筆重彩 2004年

燦爛的智慧之光。"（見李峰：《論"形似"》）這種不偏於一隅的宏觀藝術見解，有利於多元藝術風格的共同發展，滿足多層次、多樣化的審美需求。李峰的人物畫創作傾向於"以形寫神"的創作路線。他堅信："深入探索寫實主義繪畫的風格樣式，是豐富、發展仕女畫這一東方藝術形式的有效途徑。"（見李峰：《現代仕女畫的寫實主義風格》）

李峰工筆畫藝術革新成就的取得與他思路的清晰，創作主張的明確，不拘於成見的藝術思想是分不開的。他堅定地認為："藝術演變與發展的最終根源都在客觀現實之中"，"當代工筆人物畫從形式到觀念的探索應當始終立足於當代的審美文化之上"。（見李峰：《時運交移，質文代變》）這就抓住了根本。藝術創作的內核、創作靈感的火苗，來自于藝術家對客觀現實的審美感興，這種鮮活的、不同於以往的特定性質的新感受，必然催生出與之相適應的藝術表達方式和新的語言形態。

語言形態可說是藝術的血肉之軀，乃藝術本體生命賴以存在和感性呈現的方式，藝術家的審美感興、情感意念，以物化的語言形態為可視性的載體，訴諸受眾的感官。由動情而引發情感深處的思想、理念。而在繪畫藝術中線條、色彩、結構、造型，乃構成語言形態的基本"語素"。工筆畫語言形態的創新始於基本"語素"的結構方式、呈現方式的變革。而"造型"又是語言形態的重中之重。用李峰的話說："造型則是語言形態的核心"。

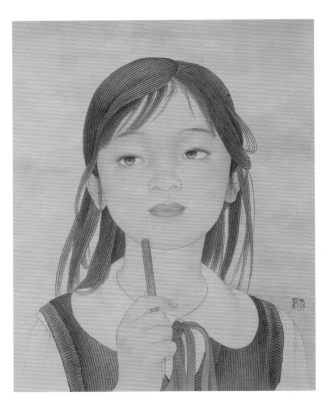

《童年》 Childhood
39.8x31.8cm 工筆重彩 2005年

李峰工筆畫的造型是綜融性的，他吸納西方寫實造型的觀念與技巧，融合於民族繪畫以線造型的傳統，他在造型中既著意保留富有內力美的線條的精微、細膩與靈性，又關注色彩冷暖變化與體面關係的相對平面性處理。他的《香蕉園》、《我的畫》、《遠芳》、《心原》、《南風》、《無題》等創作，體現出他造型語言的形態特徵；線作為他塑型、表意、抒情的基本手段，但他又揚棄了單線平塗的傳統方式，他巧妙地把線與體面相結合，既不喪失線的相對獨立的審美品性（線的內力與韌性，線的剛性美與柔性美，線的節奏感與韻律感等），又發揮線與體面結合、與色彩相配合共同塑造的能動性，他的用線有書法的功底，精練、考究、典雅，富於變化和表情性，但又決不會因炫耀技巧而鬧獨立性。在線與色的協同作用中，體面的過度既豐富又微妙自然，畫家運用他的扎實功力，每每在虛實變化、冷暖對比、意到筆不到中，體現出體面的起伏、隱顯與轉折的細膩性，既不見線的突兀，又避免了體面的生硬。線條、體面、色彩、形式結構在濃情的統馭下和諧交響，生成動人的繪畫意象。

李峰的《香蕉園》，畫來西雙版納采風的女大學生，該畫"以形寫神"，不但塑造了她的體貌、衣著特徵，而且把她的神清氣爽，既透露著聰穎智慧，又躍動著曼妙青春氣息，特別是那股子動人的生命魅力洋溢於畫面。《遠芳》則通過藏女健美、堅毅、淳樸、豪爽的形象性格塑造，表現藏民牧場轉移時，大遷徙的氣勢。這些不同類型的女性形象，體現出與古代仕女畫判然有別的現代女性題材繪畫的審美理念。《我的畫》則集中筆墨著力表現充滿美好期盼的兒童心靈世界，激賞赤子之心的奪目光彩。這是一個真實的故事：1999年澳門回歸，澳門教育界舉辦"迎回歸澳門少年兒童畫展"。有一位小學生畫了一幅：《99回歸 人人有屋住》，該畫獲得了金獎。中國文化部主辦"迎澳門回歸·中國藝術大展"，我作為大展的學術主持之一，曾邀請李峰以此為選題創作一幅工筆畫。1999年，我和李峰參加文化部派出的畫家代表團赴澳門，當時曾專程到學校訪問了這位小金獎獲得者。她美麗天真、含笑少語、性格有些內向的小模樣，給我留下極為深刻的印象。之後，我想李峰會怎樣表現這一題材呢？經過幾個月的推敲、製作，他如期拿出了這件作品。我作為在場的參與者，深感畫家把他當時的審美感動，生動地傳達於畫面。生長在澳門土地上的"祖國的花朵"、內外兼美的形象塑造，寄寓了畫家深厚的文化激情，中華文化陶冶的炎黃子孫後代，文脈相傳的心靈閃光，被畫家以形寫神的畫筆撲捉、永駐，化作時代的昂然詩意和藝術魅力。我想特別指出的是，李峰以工筆畫語言特有的細膩與精微，把"小畫家"看到來自大陸的"大人"畫家時的那種靦腆與略顯羞澀、內向與很有教養，以及那種含而不露又確實不同于內地小學生的地域文化氣質，化作了人物的內在氣韻。

從李峰的《南風》、《家》、《蕉途》、《心語》、《苗嶺映日》、《無題》、《聽》等作品，透露出他內心深處的"田園牧歌"情結。向往大自然，追慕綠色和諧生活的情愫，催生出《南風》、《家》創作系列。"有風自南來，良苗亦懷新"，不但描繪出春風化育，萬物復蘇的自然界的內在機制，而且體現出詩家天然去雕飾的詩風。我認為，這也正是李峰在《南風》、《家》等作品中的美學追求：像清風吹皺一池春水那樣自然、恬淡，像輕音樂一樣從容、和諧，無人為斧鑿之痕。南國雨林中生活的傣族女性，養殖、勞作、休憩，與綠色為伴，與自然共生，畫家借助他創造的多彩的女性群象的款款情態、嫻雅神韻及融洽相處的和睦景象，合成一個象徵性文化意象：綠色、和諧、優雅、安寧；開闢出讓困居在水泥森林中的現代人特別心向往之的田園詩境。古希臘藝術家創造出"靜穆的偉大"，當代中國藝術家追求"綠色的和諧"。李峰的《南風》、《家》；《心原》《遠芳》等作品，以工筆畫的形式語言，畫出了畫家心向往之的優雅、健美與綠色情懷。他的藝術魅力因困擾于現代生活深層的人們的渴望、追慕而愈加強烈。

李峰的色彩風格大體上可分爲濃重與淡雅兩種類型。但無論是濃或是淡，他都追求設色的豐富與統一，優雅與沈著。他追求色彩與造型、色彩與環境氛圍的高度融合，決不許色彩鬧獨立性，但又相當講究色彩的調式與品性的美。他所追求的仕女畫的人文美的魅力、生活情調美的流光溢彩，以及他所塑造的眾多現代女性美的清新明麗格調和濃郁的文化意蘊，在色彩與造型的水乳交融中、在典雅或健美的形式結構中得以體現。這在他的代表作品《心原》、《遠芳》與《南風》、《家》中可得到充分的反映。李峰的色彩觀念是開放型的，他既運用傳統的固有色，又相容西方的光源色、環境色，爲了意境的創造，也每每採用意象色。他不固守一種色彩觀念，而是東方與西方的綜融。情調、氛圍、意境才是他調遣色彩的統帥。正因爲如此，才形成他的具有現代意識的色彩個性。

李峰在其文章中指出："畫面製作的技藝性，常因被貶爲畫匠的追求而受到忽視，這並不是一種符合藝術本質和創作規律的現象"。（見《致廣大盡精微》）他重視並鑽研技法，他在傳統工筆畫著色暈染法體系的根基上，融入撞水、擦洗、機理製作等現代手法，他還自創特技。既繼承了民族色彩語言特性又加以擴展、豐富，使色彩既富有局部的冷暖變化，又有整體調子的和諧統一，既能表現古代已有的絲織類服飾等的光華與質感，又能描繪現代化纖類、毛織類衣物的性狀與色澤。他有自家的"絕活"。高寒地區藏族女性服裝色彩的濃烈沈厚，與熱帶雨林地區傣族女性服裝色彩的淡雅娟秀，完全是兩種格調，藏裝皮革的柔韌厚實、皮毛的茸茸質感，與傣裝的輕薄隨體、色澤斑斕，分明是兩種美感，都能給以惟妙惟肖的描繪。他畫物品，絕妙處不但可以視覺感知，而且流露出似乎可以用觸覺感知的意味。但又決不流於匠氣，因爲質感的描繪不以逼真、更不以技巧炫耀爲目的，而是工筆畫意境營構之所需。

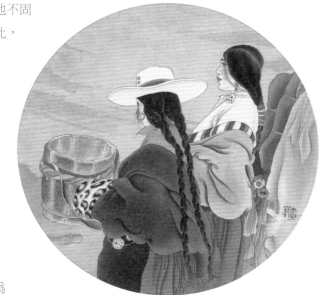

《遙寄》┃ Sent from Afar
直徑28cm 工筆重彩 2004年

中國傳統是非常重視技巧的,而且講究"由技入道"。莊子的寓言故事：庖丁解牛、輪扁斫輪、梓慶爲鐻、佝僂者承蜩等，都是講技巧的修煉、精進的，而達到物志不分、心與物冥、以天合天的精神狀態，並從而能夠得心應手、遊刃有餘、出神入化、由技而進乎道的境界。也就是藝術創造的境界。這種主、客合一的審美創造的精神，對當代的工筆畫家應當有所啓發，應當把藝術創造的狀態向著"化境"提升。比如，人物造型，已不是主體單純去追摹、再現客體物件，而是心與物忘、手與物化，得之於心、而應之於手，是以與道合之技藝呈現蘊蓄於心中的主客相融的神韻、意象。創生出經過藝術家想象力透析、精神熔鑄的藝術中的人物形象。我曾在交談中建議李峰在已經取得的成就的基礎上向這方面追求。

李峰從繪畫的本體意義、從言與意的辨證關係來認識技巧，他認爲"繪畫本體意義離不開技巧的支撐，形式缺少技巧就像藝術缺少形式一樣，最終則使自身不復存在"。（見《致廣大盡精微》）這話言之有理。也是針對那種傲慢的輕視技巧的偏見的。美術史不但陳述了因藝術觀念變革而催生出新的藝術流派的事實，而且也提供了因藝術表現技巧的演變而影響形式風格形成的範例。而有些具有語言特徵的獨創性技巧，往往成爲藝術家獨特藝術成就的某種標誌。所謂"曹衣出水，吳帶當風"，概括的就是人物畫的不同風格。而柔性的"披麻皴"（董源），剛性的"斧劈皴"（李唐）又形成了山水畫所謂的"南北宗"之別的形式因素。李峰認爲："技法形式的變革取決於觀念的更新，而觀念的更新很大程度上也可以通過技法的變革體現出來"。"繪畫技藝中也包含了藝術家的創作"，"製作與表現技巧不僅是畫家藉以表達形式美和思想情感的物質手段，同時也是形成個性化語言方式的途徑。"（見《致廣大與盡精微》）

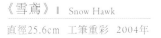

《雪鷹》┃ Snow Hawk
直徑25.6cm 工筆重彩 2004年

對於繪畫創作來說，處理好技與道的關係十分重要。埋頭於製作，把製作當成終極目的，游離了藝術的本質，斷不可取。同理，寫實技巧，對於中國畫來說也只是通往藝術本體的手段，揭示意象、神韻、意境，傳遞可感知、會意、共鳴，而又難於具體用語言指陳的內涵，表現蕩漾於繪畫形象系統中的生命情調與氤氳詩情的東西，也就是那些足以引發觀者的情感波瀾和審美激動的東西，才是藝術家追求的根本。

《詩經·衛風》中描寫碩人之美，一連串用了多個比喻："手若柔荑，膚如凝脂。領如蝤蠐，齒如瓠犀。螓首蛾眉，巧笑倩兮，美目盼兮。"但不論是詩人把美人的素手、皮膚、頸項、額頭、眉毛，比喻得多麼美好，也還是停留在形似階段。可以以寫實的手法表現之。而詩的最後一句："巧笑倩兮，美目盼兮"，才最爲生氣靈動，最爲活活脫脫，最爲撲朔迷離，也最富於精神的閃光，最能調動審美想象力。她內涵的容止的動態性、神采的閃爍流溢，氣韻的含蓄生動，要靠高超的傳神技藝，在審美想象的悟性中盡出之。從這個角度來看，生動的氣韻乃是技藝的出神入化。我想，這也是有志於構建新時期現代工筆畫的同仁們，所應當追求和共勉的。李峰是一位有潛力、有後勁的畫家，我拭目以待。

2006年3月18日 寫于北京馬坡花園天道酬勤書屋

一個唐朝的繪畫傳統在李峰手中復活著

徐小虎

李峰1959年出生於中國湖北省武漢市，也就是說在中國文化長久的楚國陰影之中，從小這敏感的小孩子在他生活的點滴、在他衣食住行，都免不了無形中被薰陶了一種特殊韻律和色彩互動的精神層次吧。

第二次世界大戰以後，歐美藝術界積極地進行抽象表現主義的繪畫，放棄了素描寫生、寫實、勾勒填彩等繪畫模式，全盤專心地去考慮、研究點、線、面、色彩本身的基本問題；而逐漸地，人物畫與風景畫都一一『落伍』了，市場再也不大看到這種展覽或拍賣了。1972年後毛澤東時代的中國大解放以來，中外交流開始了，但是中國的現代繪畫，仍然處於蘇聯社會寫實主義的鐵拳中。但是很巧地、就是因為廿多年沒有碰過中共『竹簾』幕後的資訊，西方、特別是美國，對與中國的任何訊息都抱著很大的好奇心。並且對長久已膩於抽象的歐美資本主義美術界來說，來自中共那些穿著毛裝、舉著拳頭或小紅書的人物油畫都呈現著那麼不可思議的戲劇性幼稚，對他們而言馬上變成了一個新鮮的視覺經驗，特別是帶出了毛江式那種在西方絕對不會啟發愛國感的那種誇張英雄亮身姿態的政治化產品，在西歐與北美為罕見而諷刺，無意中反而特別大受歡迎。

沿著下來，藝術市場裡就會常見到蠻多極有創意的中國藝術家，但也有些卻祇能拿出無意義的二、三手的作品、或自稱有特異功能來騙人的。至於購買者，除了少數真有鑑賞經驗的人，很多只有錢卻無審美觀；他們希望前衛或轟動的藝術品能夠提升他們的社會地位，因此會跟著藝評家而買；但西方也有邪惡貪心的評論家，把三等藝術家早期作品大量地買進來，再大大地把他們炒作起來，到了火紅時候再賣出家裡那堆三流的存貨。即使在美國紐約，偉大的畫家常與無創意的設計工匠同名、同價格。何況沒有藝術基礎的台灣！

但是李峰的繪畫卻不是沾著政治風潮而『火紅』的。它是唯美而誕生的創作品。不但是運用了相對比較陌生的繪畫傳統，又選了不擺革命姿勢的、溫柔善良的少數民族來做主題。大部份是中國甘肅南部的藏族、雲南邊疆的傣族婦女，他們對都市市場與收藏族群來說，還充滿了新鮮有趣滋味的文化因素。

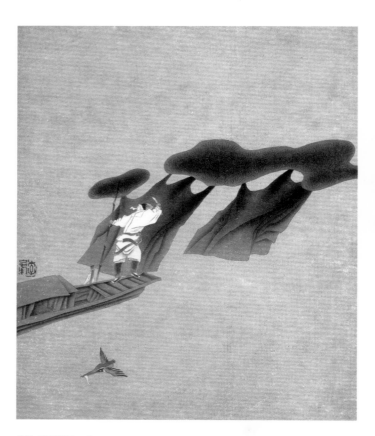

《桃花源記-1》 Peach Flower Spring Diary I
30.9x25.7cm　工筆重彩　1989年

還年輕的李峰今日已是中國畫系主任，領導著學生專攻這門工序繁複而困難的工筆重彩畫：它不但需要踏實的寫實能力，而更要有能力來掌握調配礦物色彩、動物質的膠、與正確的溫度，還要懂得色彩調和的雅俗之別。這可比油彩上帆布難作的多！這種畫類在台灣藝術界叫做『膠彩畫』，然而他是一個經過一千三百年的中日大轉彎而再度出現於中國美術史繪畫壇的畫類。『膠彩畫』或『工筆重彩畫』即台灣師範體系在戰後給『日本畫』(Nihon-ga)的中語名稱。

日本明治時代(Meiji jidai 1867-1912)所新創的『日本畫』(Nihon-ga)畫類，是世界上最具情緒性的繪畫種類之一，而其根源可以追溯到日本文化之頂峰 - 平安時代 (Heian jidai 794-1185) 所發展出來的『大和繪』(Yamato-e)；而此『大和繪』的大源頭與萌芽則遠源於中國唐朝的佛教與宮廷畫。兩種都是運用墨筆做勾勒、重彩填形，而其中又分粗獷有起伏線條、暴露著感情的『男繪』(otoko-e)以及細線條、含蓄優雅、隱藏著感情的『女繪』(onna-e)。此兩種繪畫在當時的日本產生了不少今稱國寶級的『物語』(monogatari) 型的手卷『繪卷』(emaki)。從這些畫卷以及佛畫中，我們不但能猜測早已流失的中國唐朝重彩畫的燦爛與多情多樣，也能從日本繪畫史中不斷地追隨它的發展、演變、分枝的過程。有趣的是，在『明治維新』動力下日本全盤地把文化更新的同時，中國知識份子也多少體會到了更新的必要性，也整群地往日本留學去了。這一舉就提共給民初中國繪畫一個新刺激，這一批歸國畫家如高劍父、高奇峰兄弟在廣州突破出使用重渲染、多彩色來抒情的『嶺南畫派』；又在江南地區啟發了傅抱石把精緻細膩的感情表達於他帶回來那些充滿色彩渲染與新穎型的畫面上；張大千又把久已從南宋逐漸消失的水墨畫潑墨、與有表情的渲染法帶回國內，使華人長年枯燥的繪畫突然大大地醒著起來，如同魚跳回海水一般。

《桃花源記》 ∎ Peach Flower Spring

31.5x25.8cm　工筆重彩　1989年

徐小虎 (Joan Stanley-Baker)　　　　A.D.1934

徐小虎有歐亞雙重血統；德國母親和擔任中國政府官
員與外交使節的父親，使她自幼成長於多語言及跨文
化的環境。其方法學的條理，則得益於在普林斯頓大
學攻讀藝術史碩士課程時的訓練。之後又回到校園，
在英國牛津大學完成碩士和博士學位。
徐小虎曾任職於美國、加拿大和台灣的博物以及美術
館與藝術中心，並且曾任教澳洲、加拿大和台灣的大
學。她的著作包括《日本藝術》（1984年，Thames
and Hudson出版社世界藝術史系列）、《中國文人畫
之東渡日本》（1993年，密西根大學出版），以及吳
鎮研究，Old Masters Repainted, Wu Zhen (1290-1354)
Prime Objects & Accretions（1995年，香港中文大學
出版）。

文革後中國繪畫比較自由化以來，雲南地區如雲南美術學院，出現了工筆的人物畫，
常以多色重彩來描寫邊疆或神話裡幻想的人物來做題材，以美貌、多曲線、如同舞蹈
的柔雅姿態般的美人或仙女來主導著畫面。即使不是直接留日，也應就是由書籍刊物
中目擊到的『日本畫』與『膠彩畫』，其影響可見於雲南美院的繪畫，也從李峰的工
筆重彩人物畫中湧出。

在他那動人的『留蔭』、有微妙渲染的「空」區中，我們感覺到『日本畫』所強調的
寧靜，它沉默中隱藏的情緒。這種表達模式是以前的中國傳統人物繪畫裡，無論是重
彩或文人型的，都是完全找不到的。為什麼呢？就是因為情緒性（emotionality）是中國繪
畫上千年所迴避的，然而它卻是日本繪畫的宗旨或特徵。中央美術學院的邵大箴在他
2005年的「意象造型和高雅畫境--李峰的工筆重彩畫」『一文中提到，「他[李峰]採用
了古代傳統壁畫中的構成因素，有意識地壓縮畫面的三度空間，以加強平面的視覺張
力；同時採用優雅明快的色彩，輔以較強的黑白構成對比；由於塊面分割與線形處理
舒暢、簡潔和線條沈穩、凝重，使畫面的大效果在優美、明朗中不失厚實感。」這都
是『日本畫』傳統含蓄內斂的『女繪』特徵，特別是邵氏所暗示的那些抽象的情緒價
值，指的是透過畫面本身（而非人物臉上或姿態的表情），藝術家能帶出感情價值：沈穩
、凝重、優美、明朗、厚實感。這是新中國繪畫的成就，也是李峰的特殊貢獻。

『日本畫』那麼動人的奧秘在其運用渲染的技巧，常常在畫面裡製造出一塊猛然的開
朗、由較有色的邊緣逐漸把色彩淡化，同時往中心點最亮的那塊空間去。此舉之效果
給畫面空間一種生命感 - 然而它是微妙的、安靜的。這種以抽象渲染而創造的生命感，
倒是李峰還得琢磨的功課之一。但李峰的天才是多元的，除了抒情，他還有極熟練的
攝影式寫實主義（photo realism），如同80年代及熱門的幻想繪畫，把山水與人物混合起
來、讓我們從山水裡看到人物或相反地從人物裡看到大自然，像南德大師赫赦曼
（Friedrich Hechelmann, 1948-2007）或加拿大的鞏薩威斯（Rob Gonsalves, 1959）年生等夢幻
主義畫家的畫品類型。對李峰來說，將《我的畫》中小女孩的兩邊的柏樹叢、或者《
遠芳》那白牛的長毛或地上冒出那些不同的草類，它們都是既寫實又各自有其抽象的
韻律 - 把這種繁榮又重複著的背景因素稍微整理一下，馬上就能從其中看到飄揚長髮的
美女或各式各樣的夢幻形狀一一浮現出來。但是目前李氏尚未把他的畫風固定下來，
也可能是還在探掘不同的潛能吧。

目前他畫裡的美女，都帶著同一個無表情的臉孔，眼睛張開但是內斂著在夢中發呆，
也因此不管畫中有二個或五六個人，她們彼此是沒有心理上的聯繫（psychological link）
的。這種空虛感是中國傳世古代人物畫贗品的特徵；因為大多為摩本、臨本，造假者
永遠不會把人物彼此的眼神畫的對。反而，真的古代人物畫 - 如同敦煌壁畫上所能見到
- 都充滿著人間激動的活力，即使動物鳥類都會有活潑發亮、有彼此聯繫的眼神。可惜
現代人都把那些毫無活力的傳稱唐代「周昉」、「張萱」等的贗品視以為真而學習之
，也把那無來往的眼神放在自己的畫裡了。效果是個擁擠而陌生的社會表現、脫離愛
情的溫暖、串入寂寞無奈的心靈環境中。可是這也可能是反映了當下的李峰本人在他
藝術生命驚人快速的發展的過程中，所感覺到的孤獨與悲哀吧。在《李峰國畫作品精
選》中看到他一張彩色素描，從背後畫的透視性裸女；構圖又如同一塊石頭，前景的
臀部最大又發光，由而襯出的線條與明暗充滿著詩意與感情，除了不幸的紅指甲外，
整個畫面的光線與陰影達到了極美又溫暖的境界，也說明了李峰在畫美女之外實有大
師的條件。

他現在很多畫面中可以看到的人與動物在草原或樹下停著、呼吸著，無表情的臉孔可
能藏著無可測知的感情。也常見一女的背後，往觀者的前面望著、望著，在極度的沉
默中設立她獨自的盼望。如『心原』、『南風』、『香蕉園』等，給觀者打了一個謎
語：『她是誰?李峰的秘密愛人?』然而此等想像其實可能來自李峰自我探討的過程：「
我是誰？什麼是我的真面目?」這是李峰將會為自己逐漸釐清的。目前他掌握著多面
的技巧、主題、與色彩的優雅配合，其繪畫眼前的宗旨是處於一個極度豐富鮮豔、充
滿物質價值的視覺世界裡的精神，但它的沉默內斂、寧靜，卻仍舊是李峰存在的主宰
。

文選目錄
CONTENTS OF ESSAYS

作品目錄
CONTENTS OF ART WORKS

WORKS

《遠芳》| Fragrance from Afar

172x170cm

工筆重彩

1997年

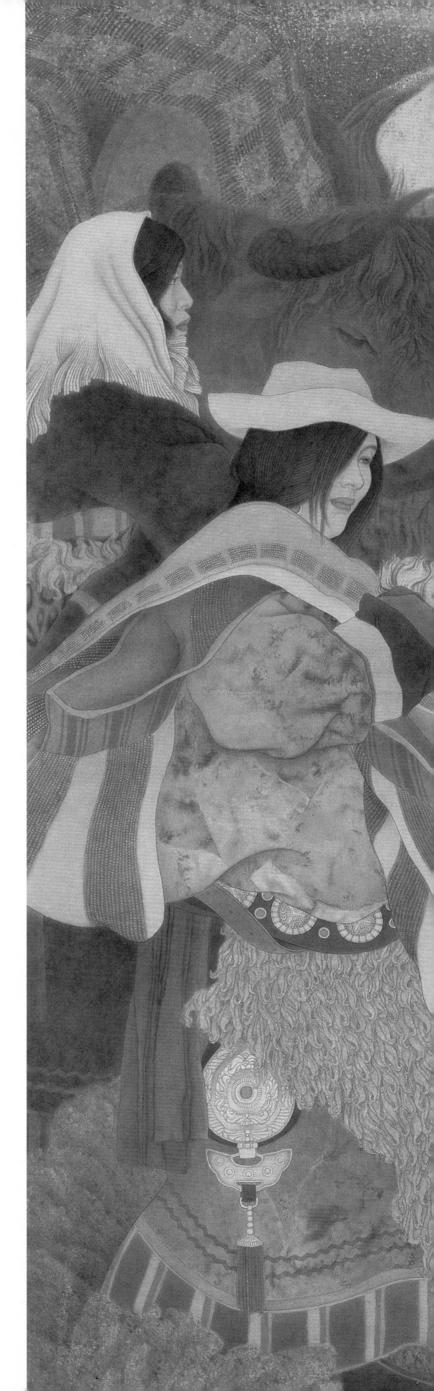

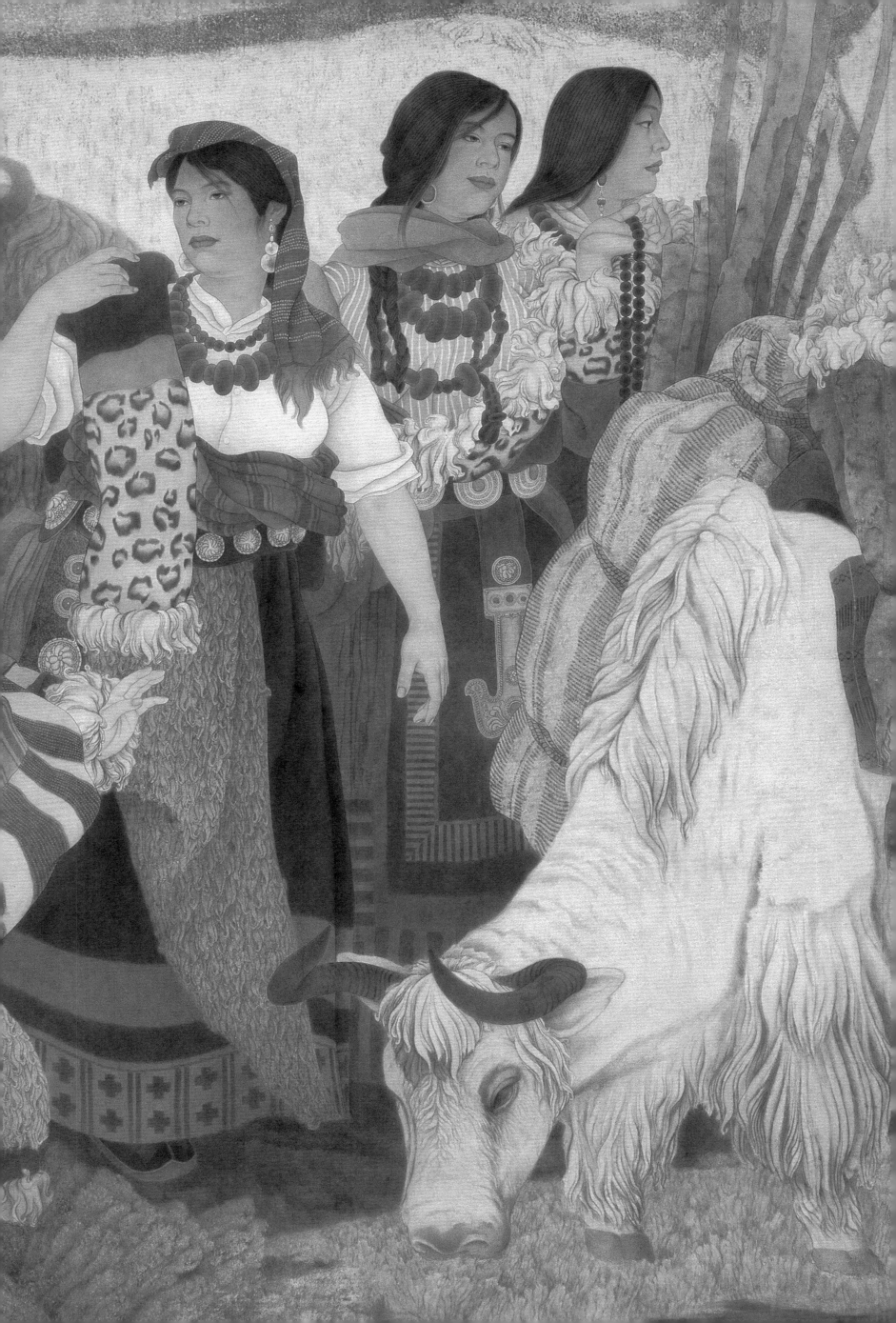

《南風》| South Wind
230x141.5cm
工筆重彩
1999年

《南風》獲"第九屆全國美展獲獎作品展"優秀獎並獲"第九屆湖北省美展"銀獎。
作品在構圖上採取不規則對稱的方法，營造出一種和諧的平衡感，而且透過人
與物在畫面上的堆疊，展現出具有層次性的深度，再搭配南方農家的暖調色系
，產生一種人與自然和諧交融的畫面。

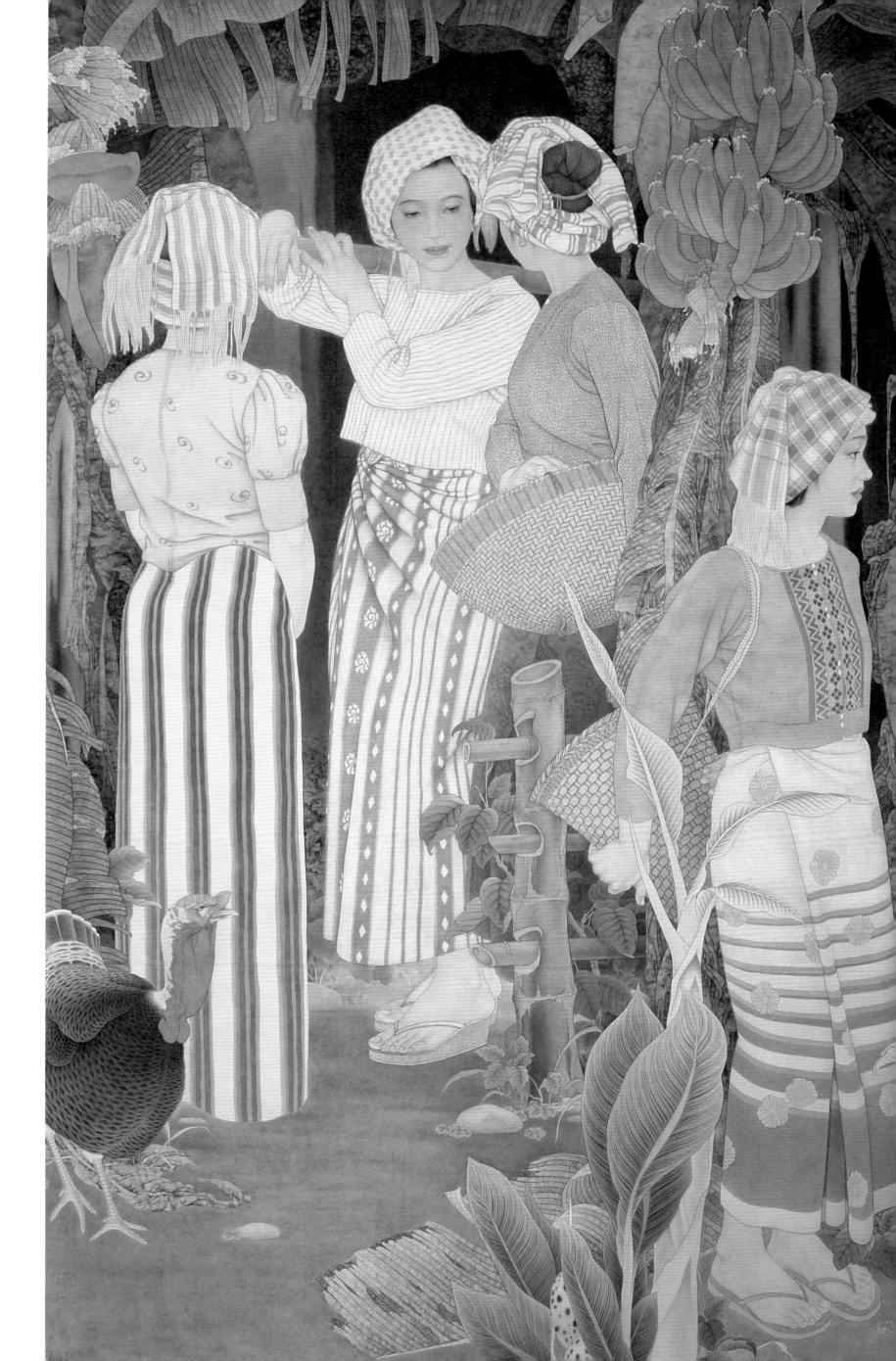

《家》| Home
205x121.6cm
工筆重彩
2001年

《家》獲"慶祝建黨八十周年全國美展"優秀獎並獲"慶祝建黨八十周年湖北省美展"金獎。田園牧歌式的永恒心像是其審美意識的核心內容，少數民族地區平靜恬適的生活情景是其藝術表達和思想傳遞的基本載體。在那遠離喧囂的大自然的懷抱裏，在質樸樂觀的少數民族氛圍中，可以領悟到一種令人神往而悠遠平淡的內心獨白，這裏使靈魂得到沐浴和放鬆，是都市生活無法感受的精神家園。

在傣族系列作品中，明確地反映出作者力求在現實與理想、真實與虛擬之間尋找切合點的審美意向。畫面採用動靜相宜，客觀取形、主觀造景的構成方式，力圖將自然環境家園化，以表達人與自然和諧完美的生存狀態，在仿佛熟悉的心儀傳遞中擁抱生活。如《家》這幅畫，有意取消了作為院牆的竹籬笆，而將火雞及處於小憩或飼養家禽的傣族婦女安置在一片幽深的香蕉林中，使家的意境得到延伸。

這組作品大膽吸收了壁畫的構成因素，有意識地壓縮畫面的三度空間，加強二維的平面視覺張力；色彩力求優雅而不豔俗，清新明快，並強化了黑白構成對比；在團塊分切與線形處理上簡潔自然，線條沈凝，節奏關係井然有序，保證了畫面明朗厚重的視覺效果；豎式構圖較好地實現了視覺的流暢性和完美性。人物形象優雅自然，著力於線與形關係的有機整合，使主體人物既有線的清晰輪廓又有面的恰當過渡，力圖表達畫家為之神往的靜虛之境、純淨之美和理想的精神世界--苦心尋找和經營一片讓心靈安慰的芳草地。

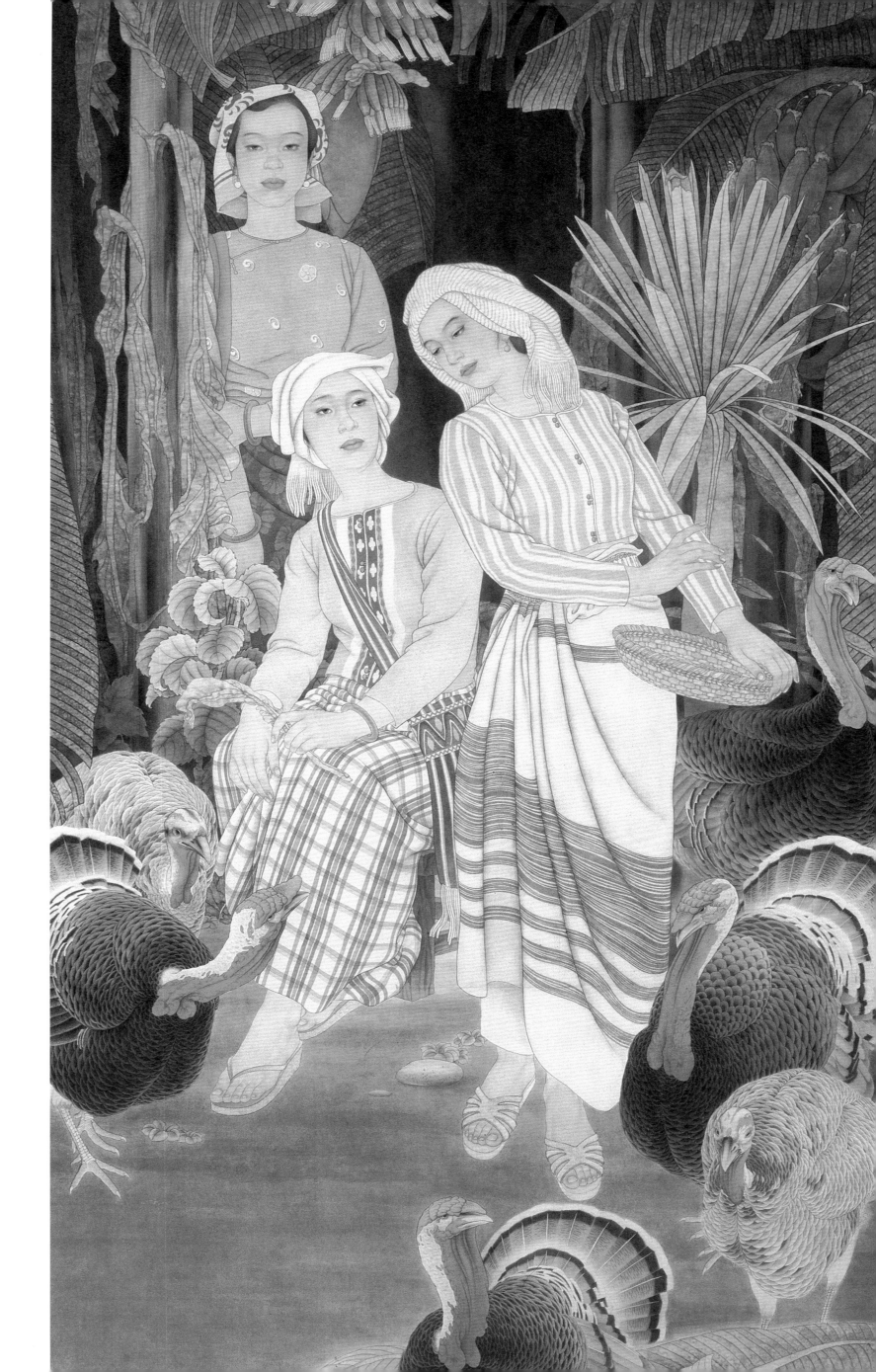

《憎憎版納》I Serene Ban Na
241x163.5cm
工筆重彩
2007年

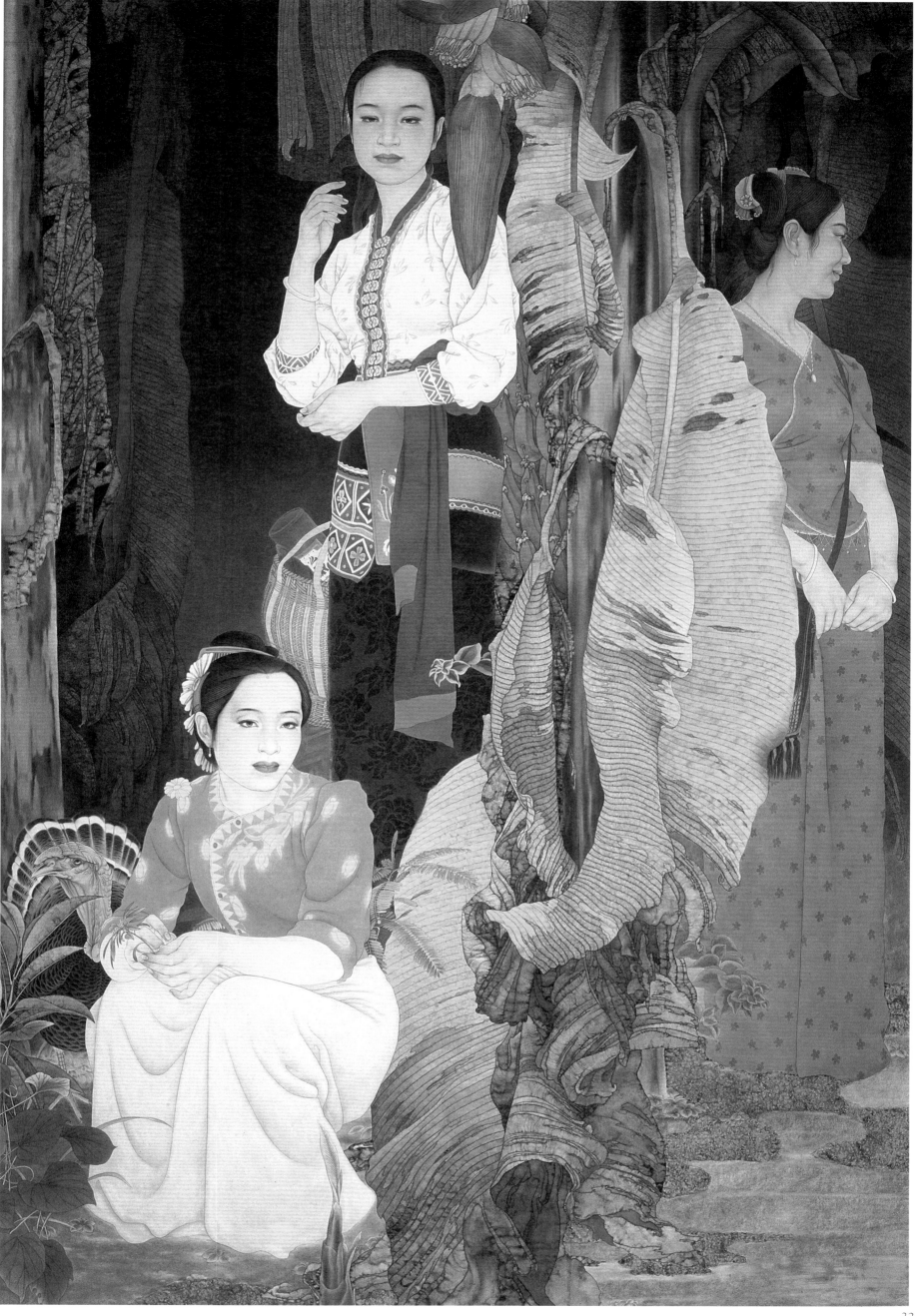

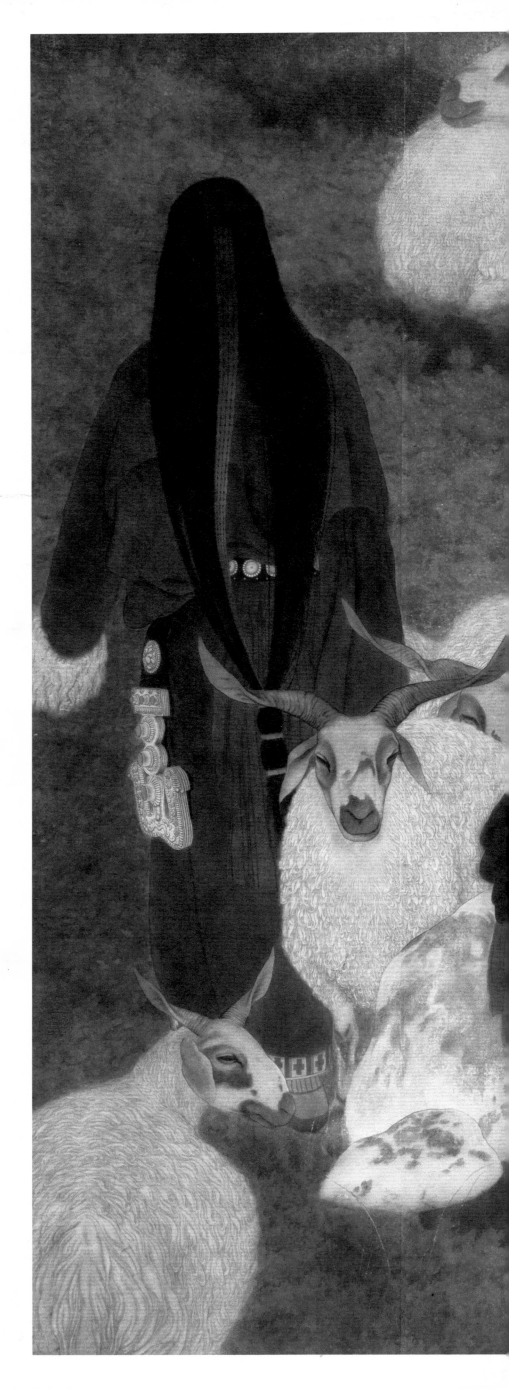

《心原》I Land in My Heart
180x180cm
工筆重彩
1994年

《心原》爲"第八屆全國美展優秀作品展"獲獎，作品並獲"第八屆湖北省美展"銀獎，
由中國美術館收藏。

在甘南藏區恢宏壯麗、質樸凝重的遺風，古戰場百萬軍旅般轉戰南北的生存氣息感染
下，在這使人心血沸騰，激動不已的景觀、氛圍中，不僅感到自身個體如滄海一粟般
的渺小，同時也體驗了藏區人民寧靜至遠、飄蕩著對生活充滿美好憧憬的悠揚心境。

藝術是情感的投入，是心靈的感應；形式是藝術的表像，不是藝術的靈魂；情感與心
靈是人性最本質的反映，而形式只有在真正反映情感和心靈的前提下才具有其本質的
意義，否則，形式只能是嘩眾取寵的軀殼。

《心原》這張畫所要表現的是甘南藏區婦女的遊牧生活，作者希望以人物、羊群、草
原做基本形象元素，以靜爲主、動爲輔的構成方式爲畫面基本旋律，反映大草原的遼
闊遙遠，遊牧生活的祥和安寧。把羊群和草地有機地組織起來，豎向平面拉開，使羊
群的走勢由人物的左右發展到人物的上方，象徵白雲環繞、天地合一的意趣，把莽莽
草原和浩浩長空化作心念聯想，融無限於有限，在尺幅畫面的空間中馳騁飛揚；畫面
的左側安排了一個走向草地、羊群的人物背影，有靜中取動的意味，而且隱喻著人、
大草原和牧群生物密不可分的原生關係--歸生活于無爲，還人性于自然。

24

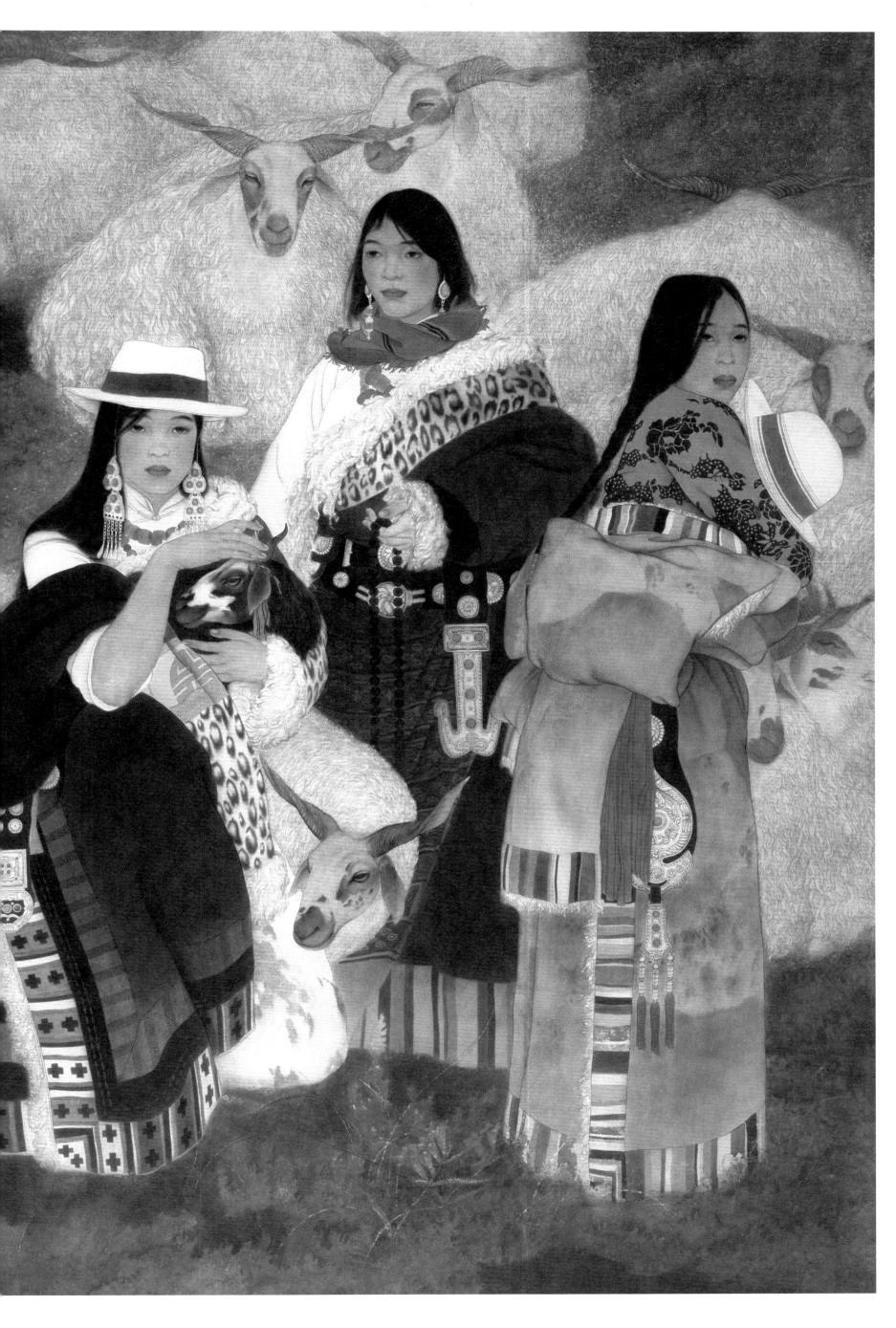

《香蕉園》| Banana Orchard
200x120cm
工筆重彩
1998年

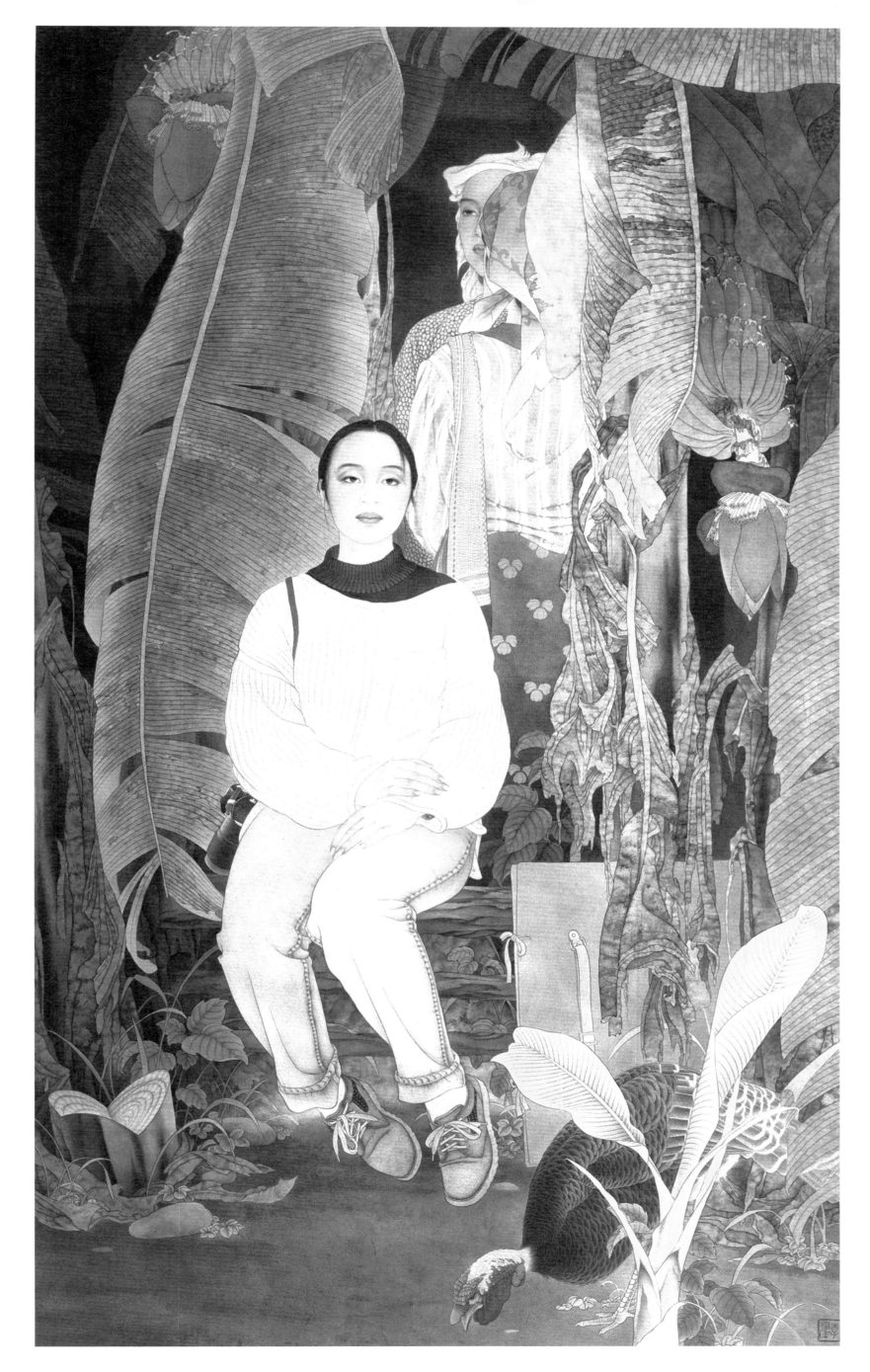

《心語》 | Language of the Heart
200x91cm
工筆重彩
2004年

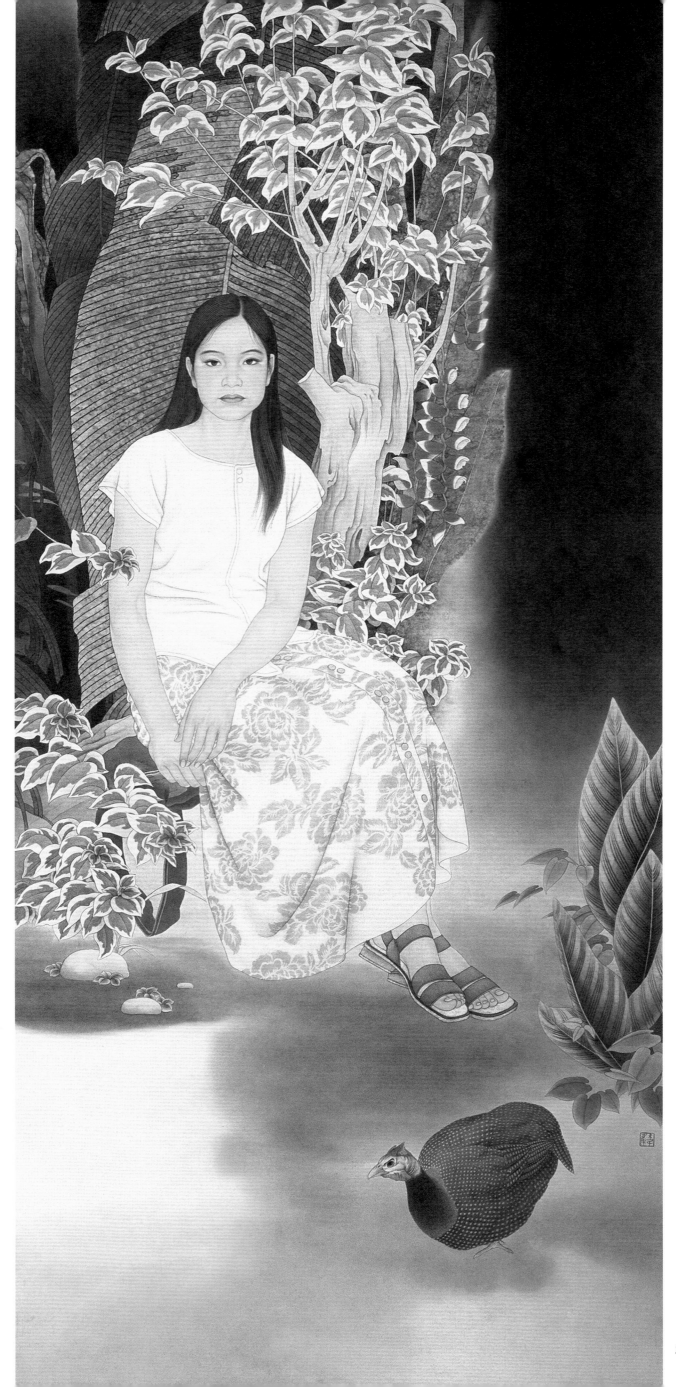

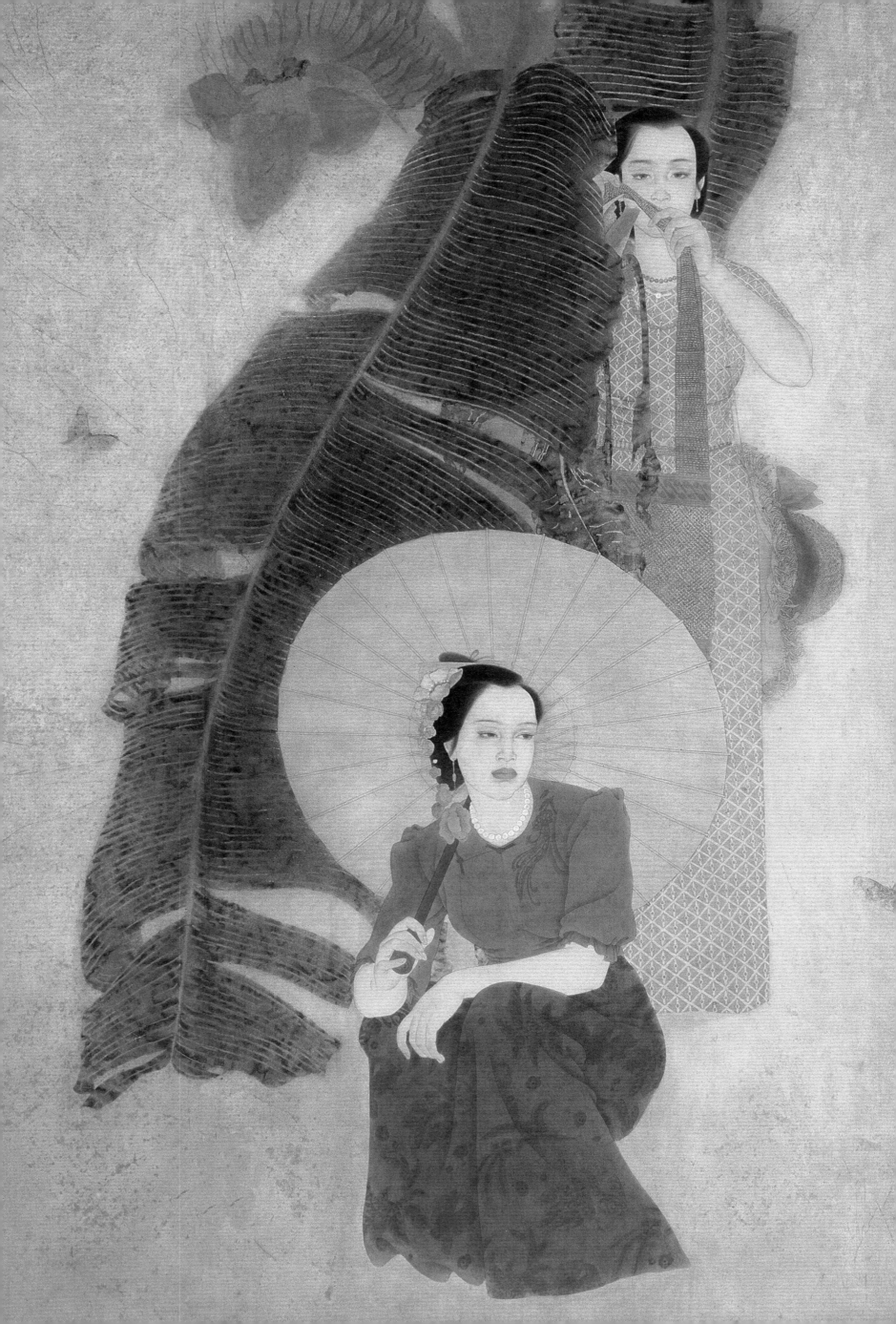

《留蔭》 I Letting the Shadow Stay

154.8x149cm

工筆重彩

1992年

《留蔭》獲紀念"在延安文藝座談會上的講話"發表五十周年湖北省美展優秀獎。
作品以中國水墨中的留白來作為畫面的平衡工具，右邊的大片鋪底空白處，與左
邊的婦女襯著芭蕉葉的佈局，形成一個強大對比。右邊的空白路徑加上幾隻小蝴
蝶，彷彿在故事中的某個片段，主人翁在路程中歇息了一會兒，拿起紙傘，或是
躲在蕉葉下，一前一後的姿態，與紅色染裙陪在綠色的大片葉下，讓左側畫面雖
然簡單卻很有層次感，在這一看似簡單的構圖中，再次見識了工筆畫家對於精準
構圖的優秀能力。

《翔》I Soaring
149.8x132.2cm
工筆重彩
1991年

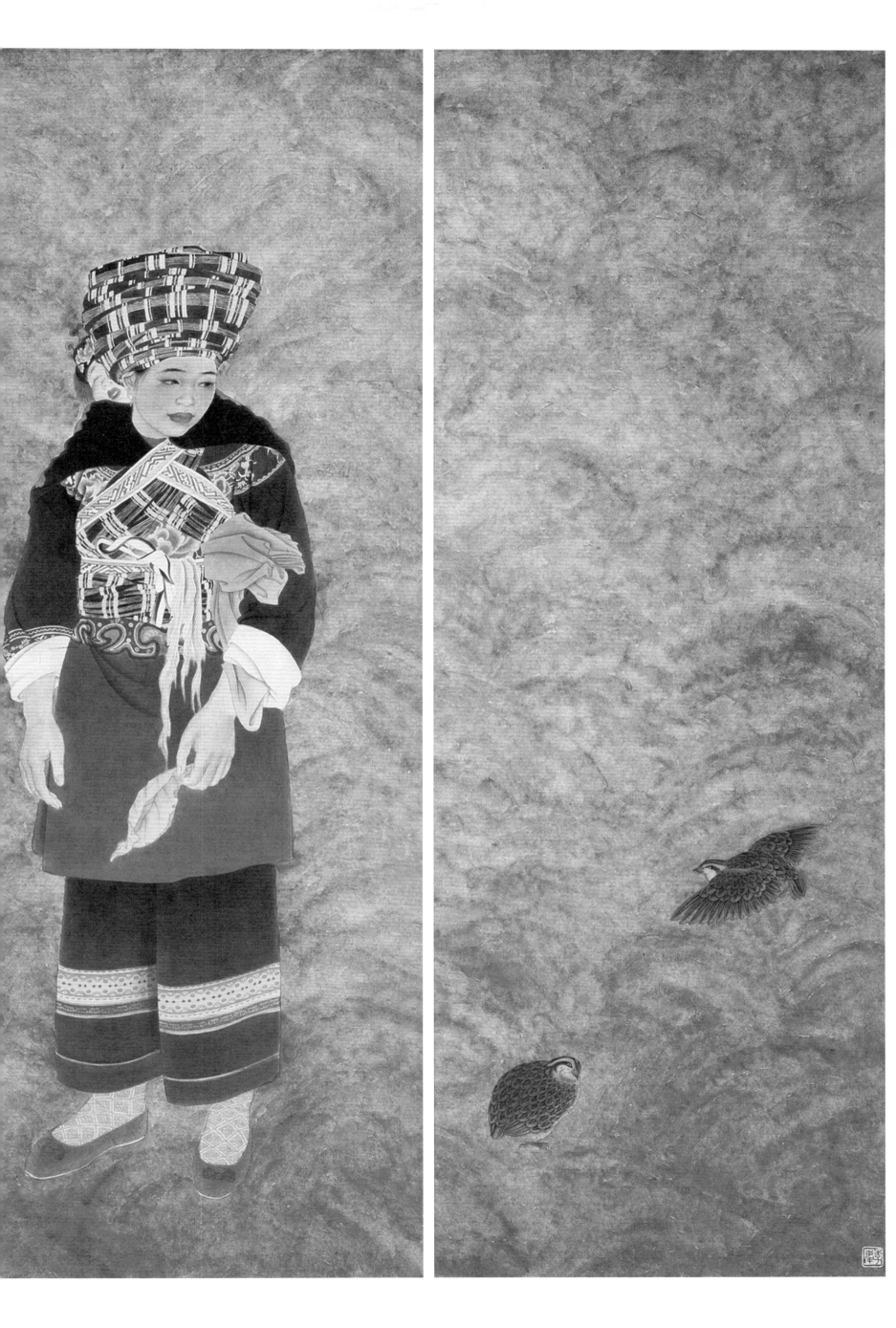

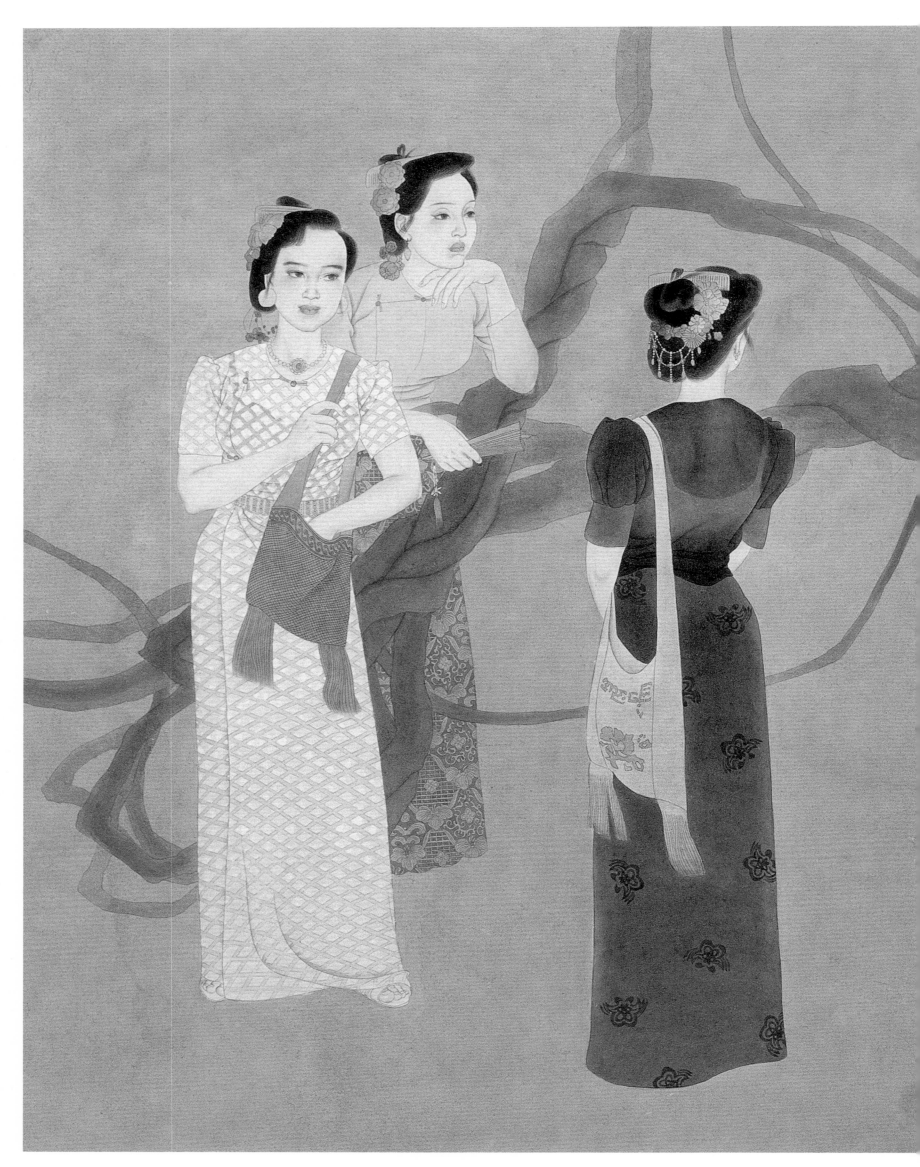

《憩》1 Resting

127.4x79cm 工筆重彩 1990年

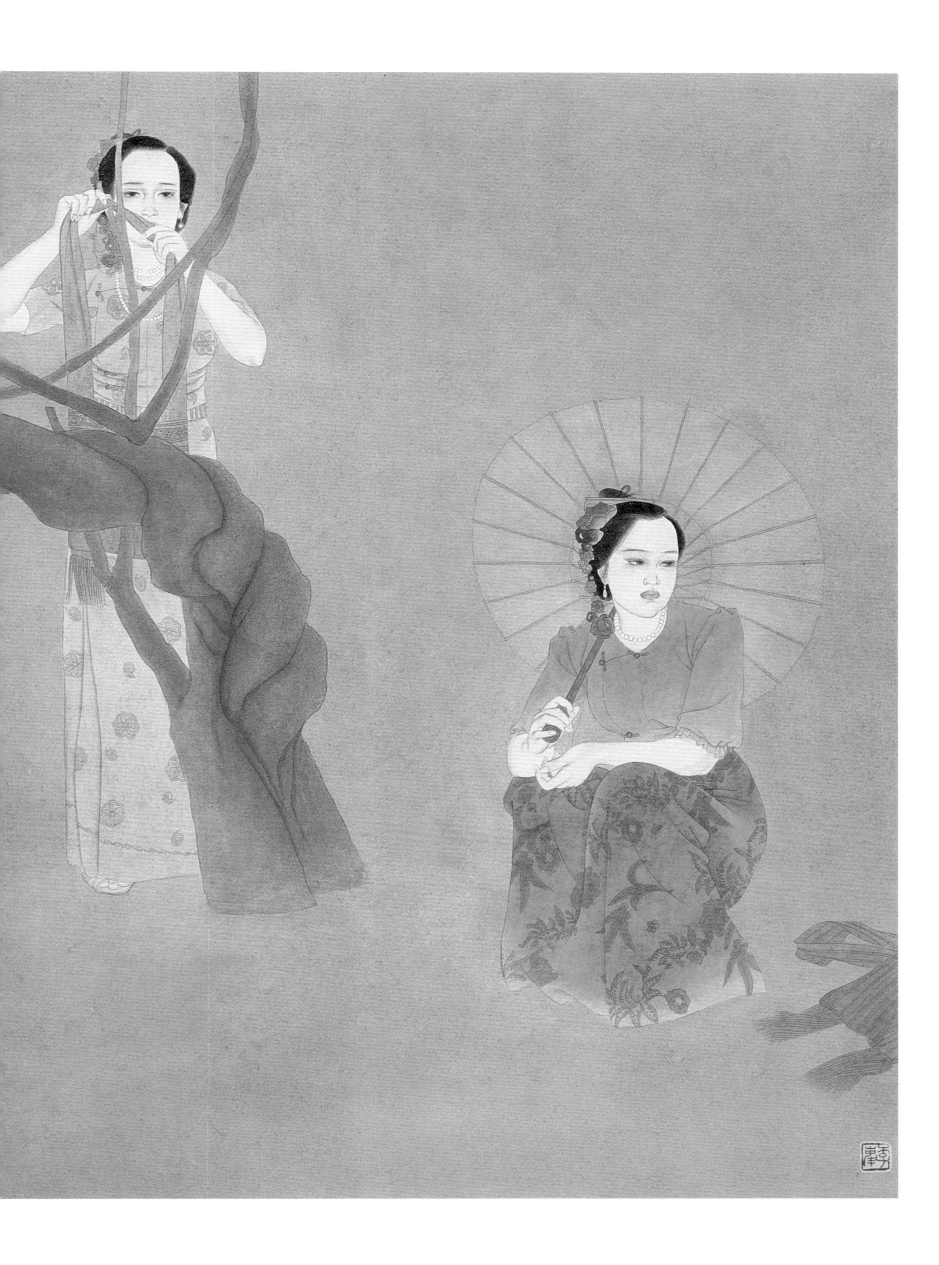

《苗嶺映日》 | Sun Shining on Miou Tribe Hill
160.5x161cm
工筆重彩
1993年

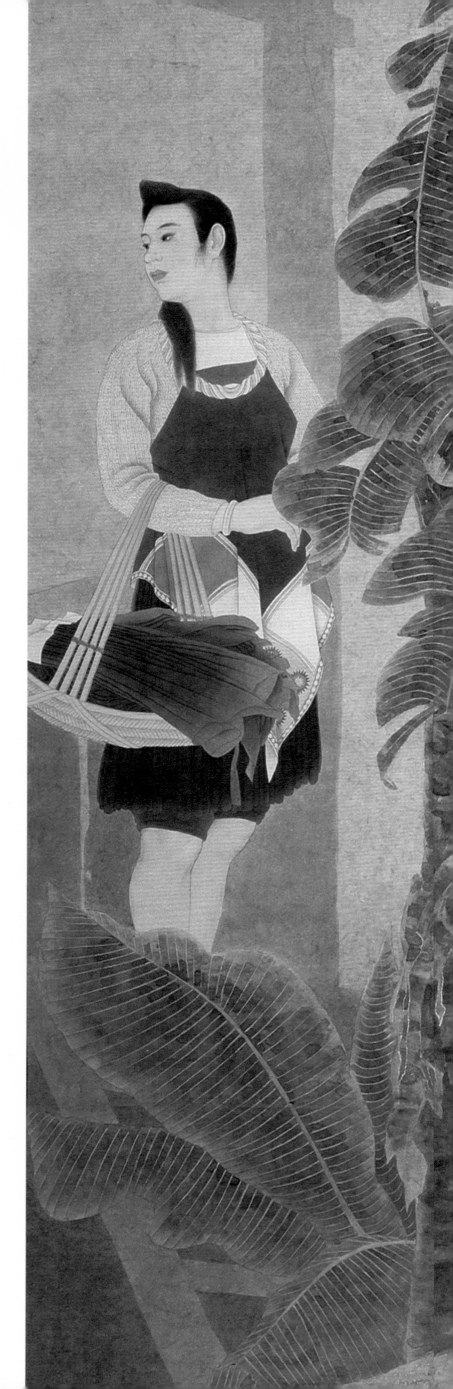

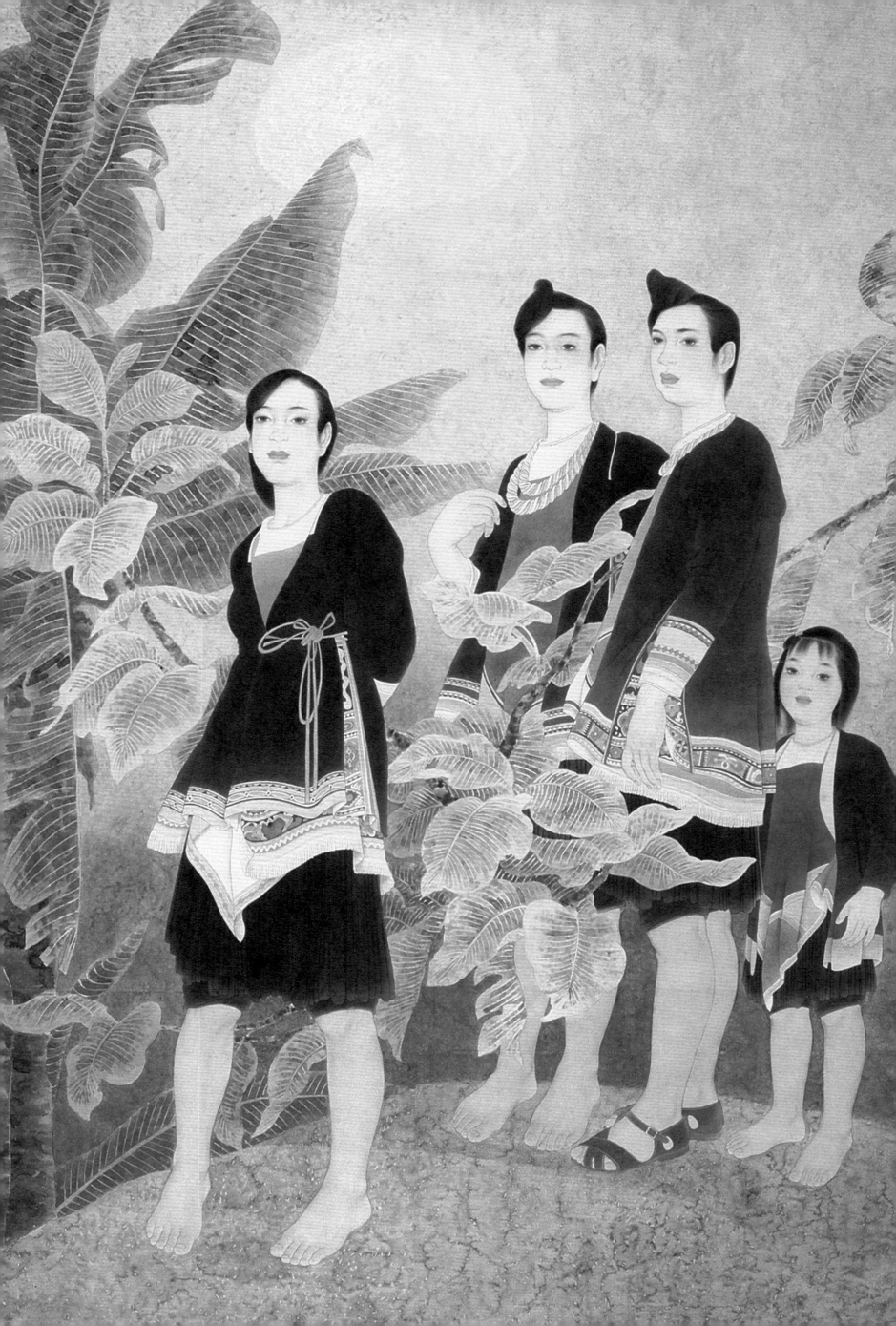

《我的畫》I My Picture
180x125cm
工筆重彩
1999年

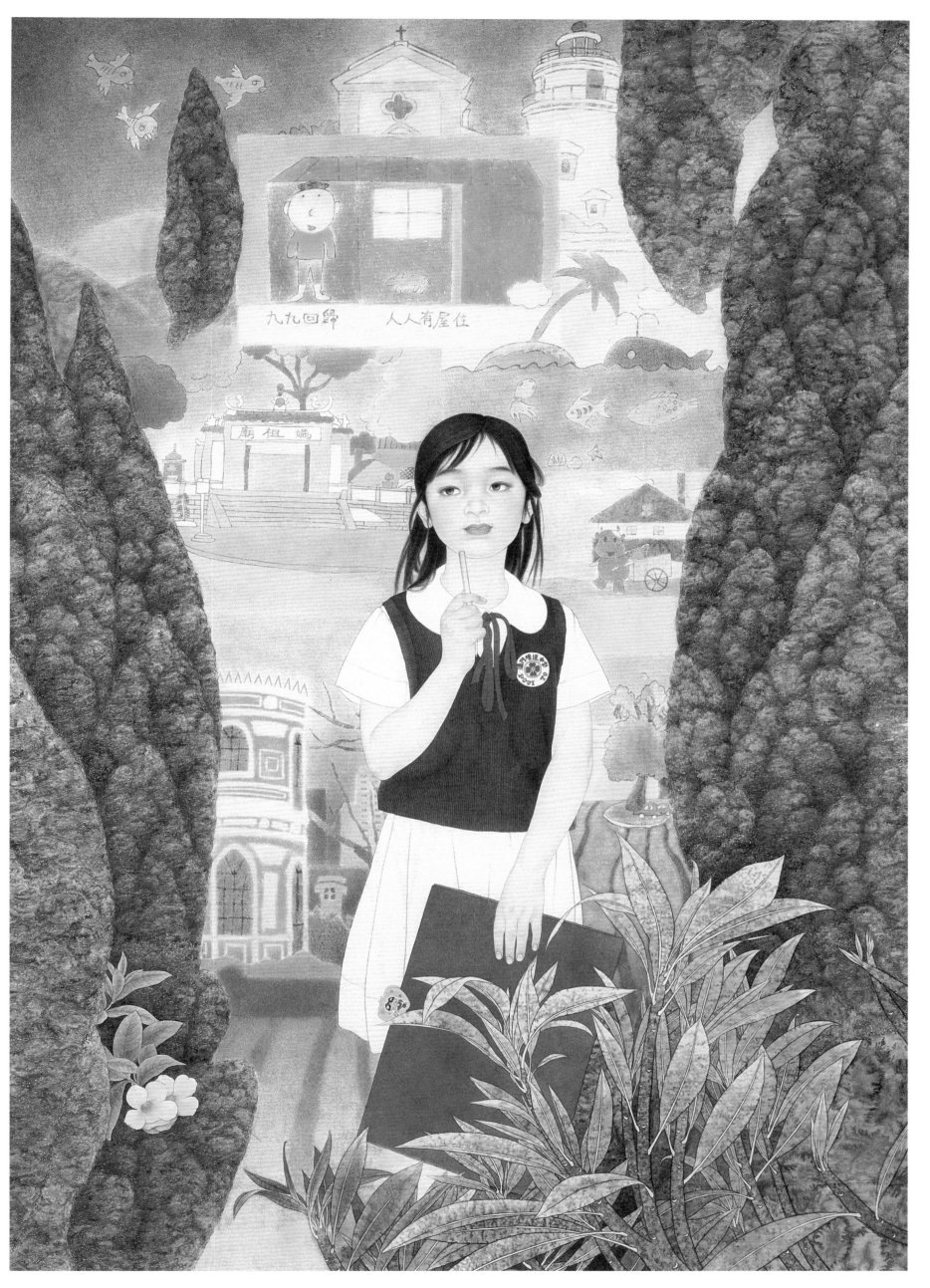

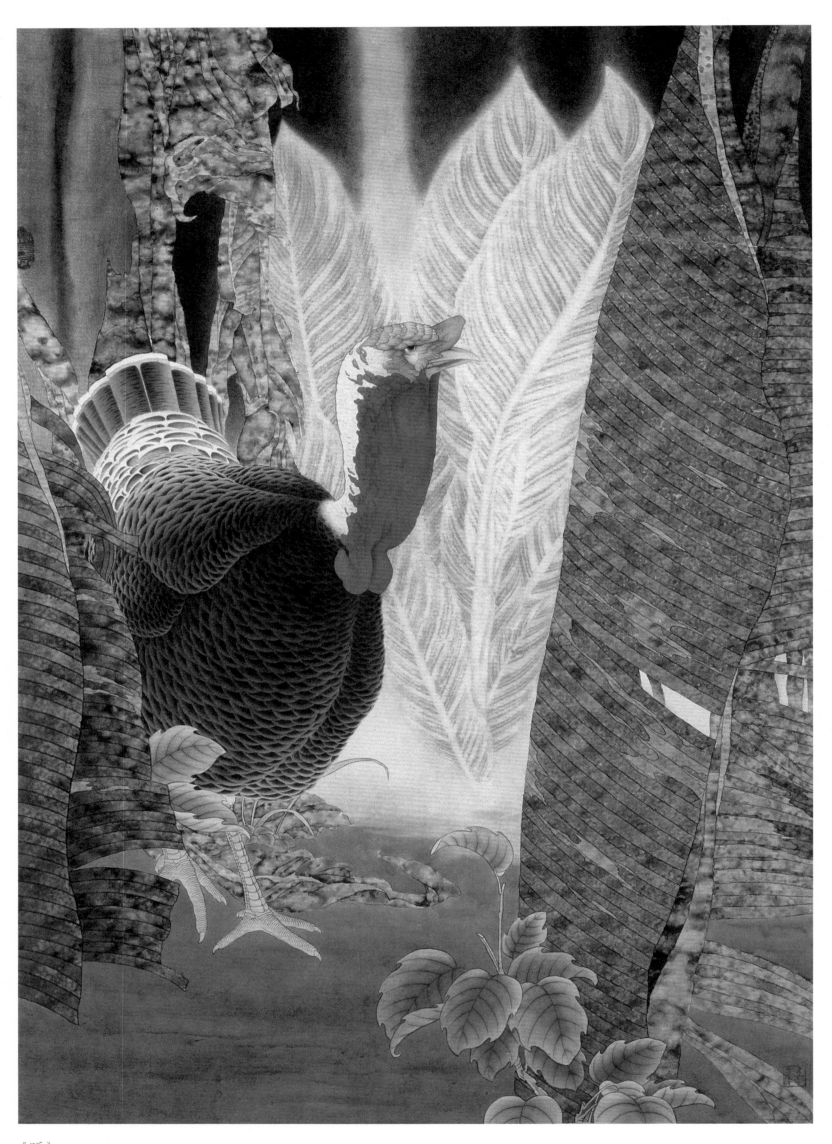

《听》 I Listening
100x70cm 工筆重彩 1999年

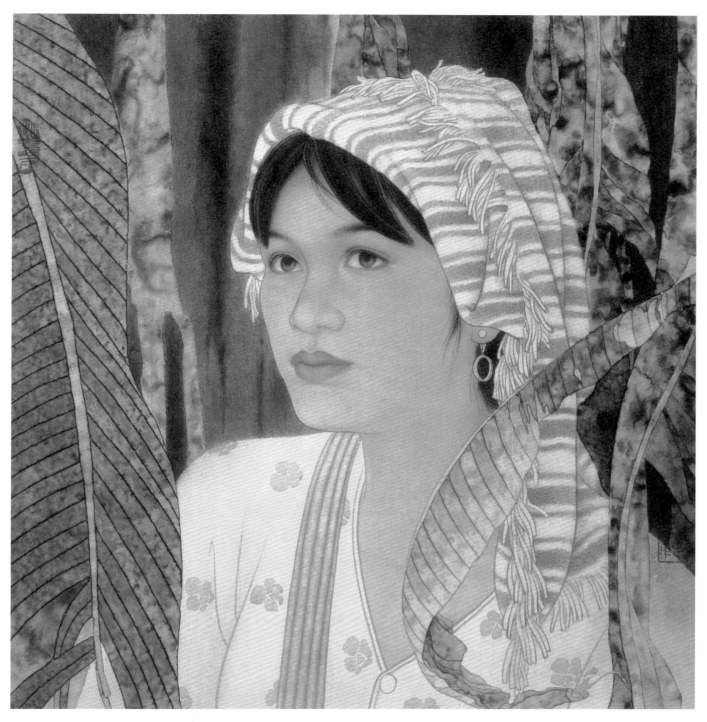

《無題》 I Untitled

45x45cm 工筆重彩 1999年

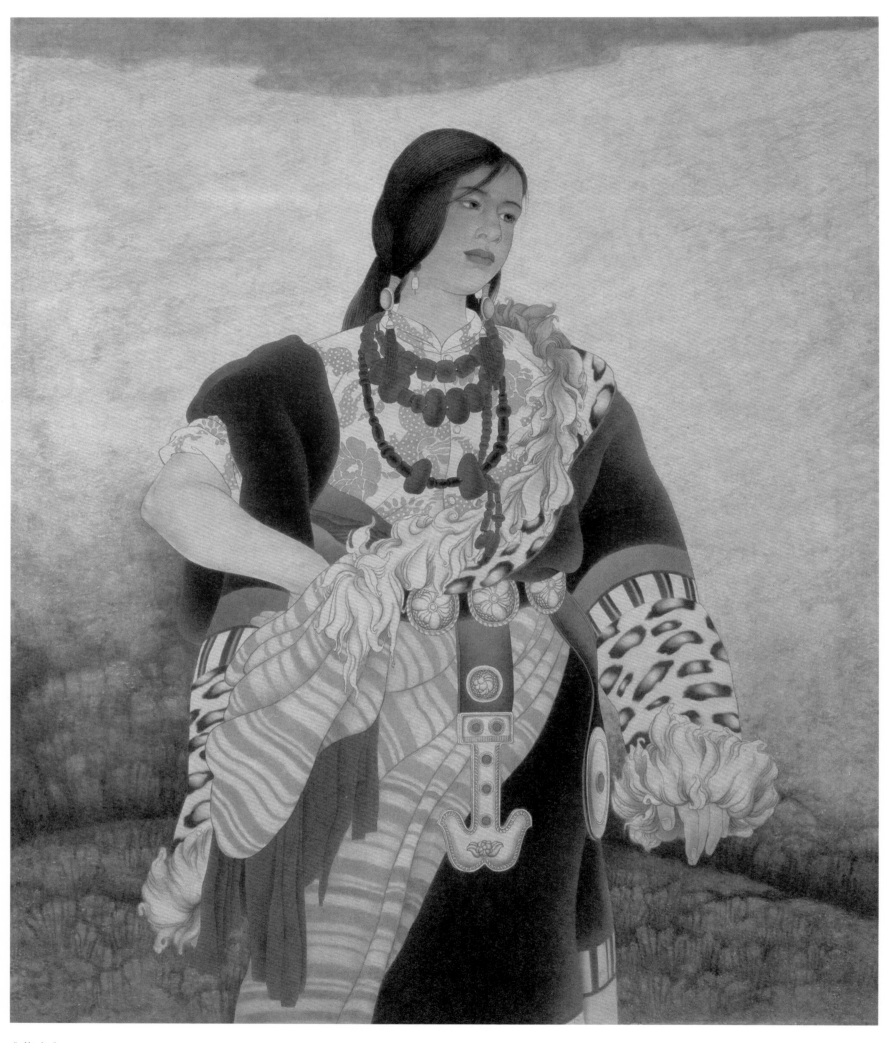

《藏女》 ┃ Tibetan Girl
97x80cm 工筆重彩 1997年

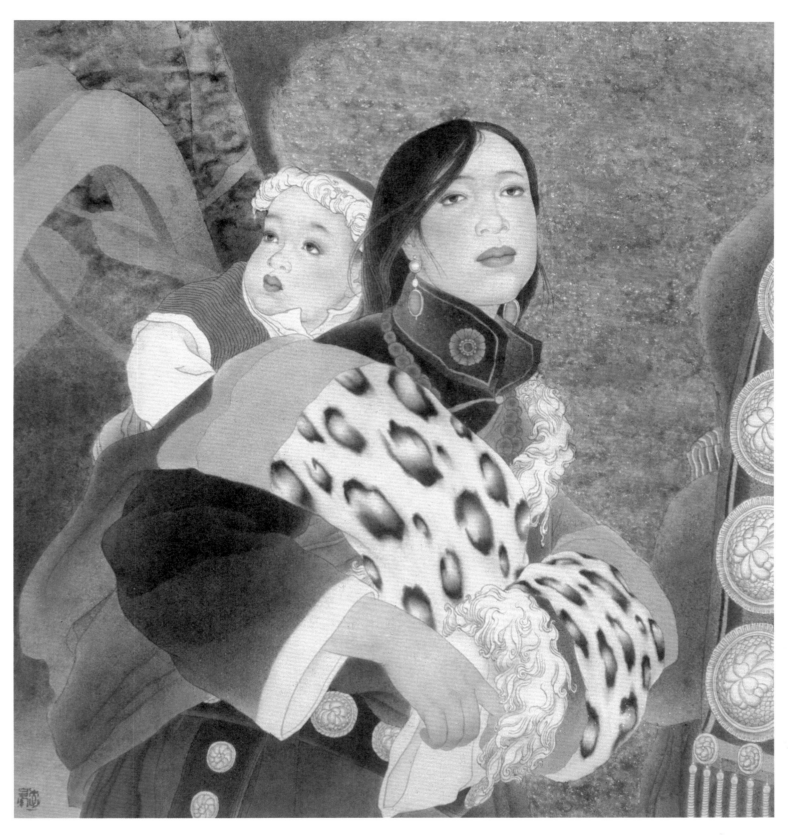

《母子》 I Mother and Son
50x45cm 工筆重彩 2002年

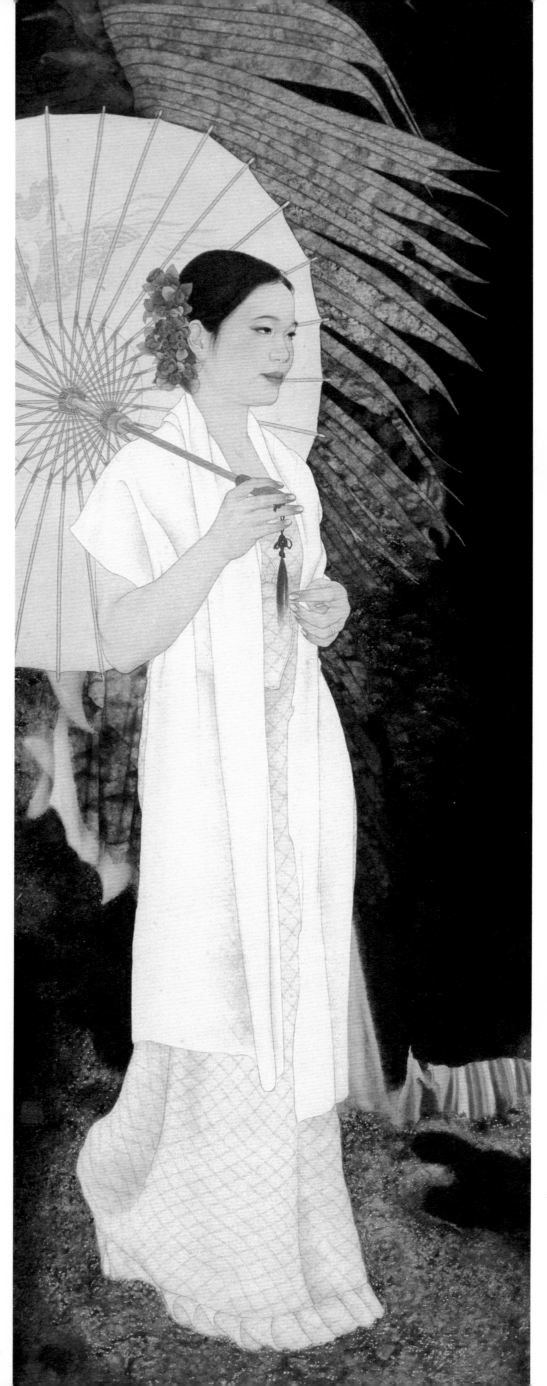

《晨曲》| Morning Song
122.5x43.5cm
工筆重彩
2007年

《落霞》 **I** Failing Rays of Sunset

123x44cm

工筆重彩

2007年

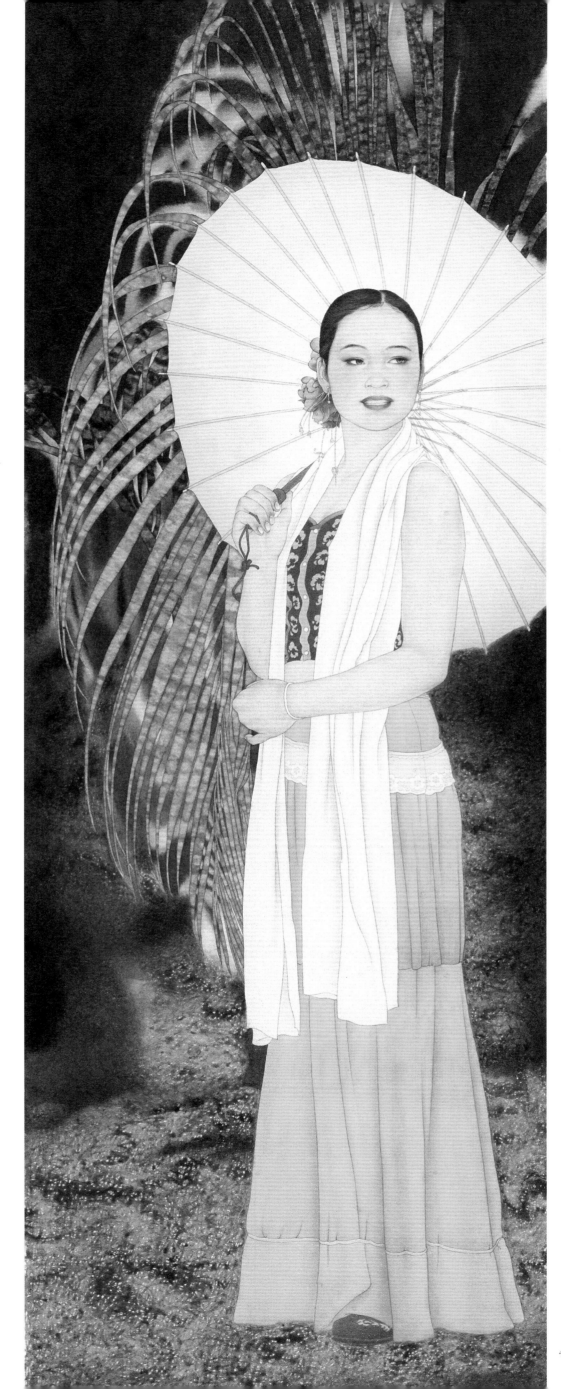

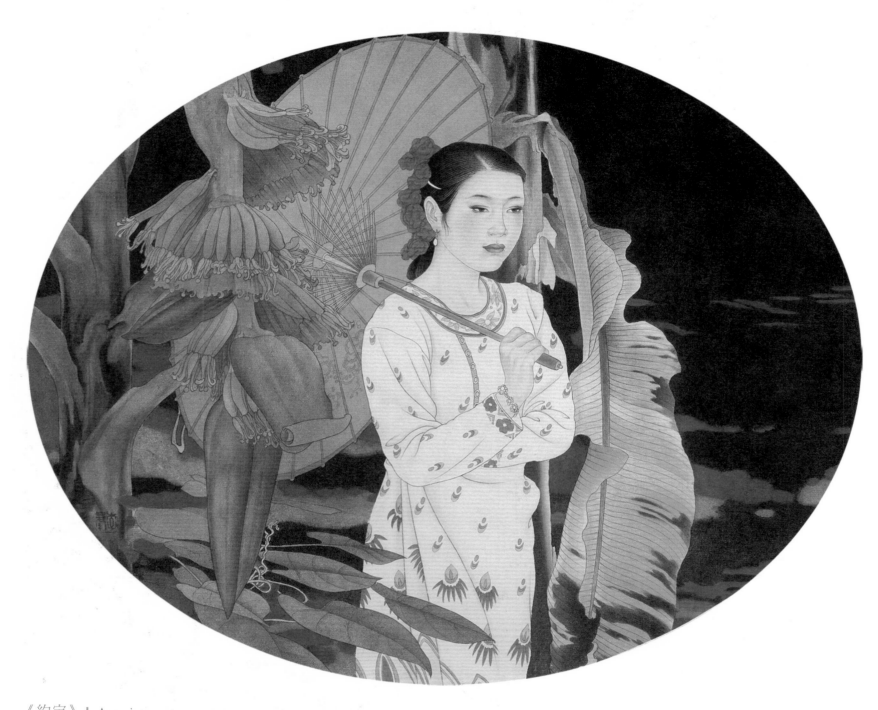

《約定》 Ι Appointment
橢圓50.6x40.8cm 工筆重彩 2004年

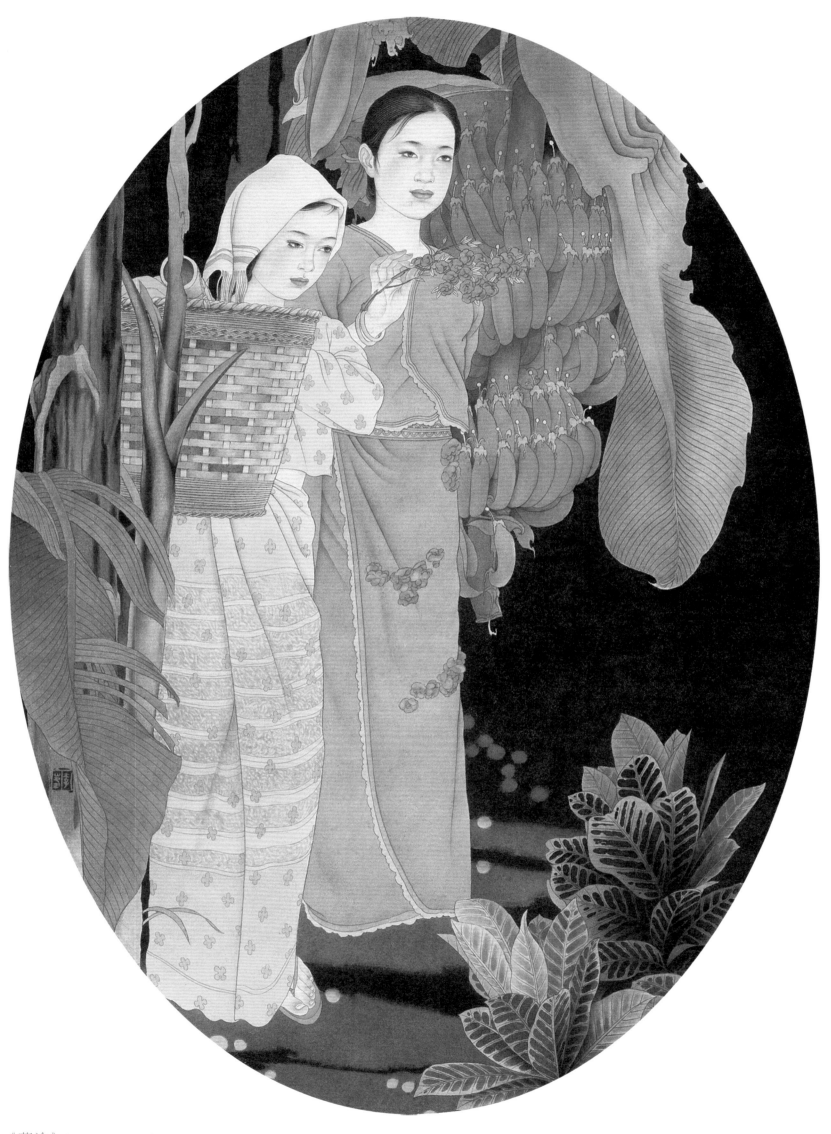

《蕉途》| Banana Road
橢圓69.7x50.5cm 工筆重彩 2004年

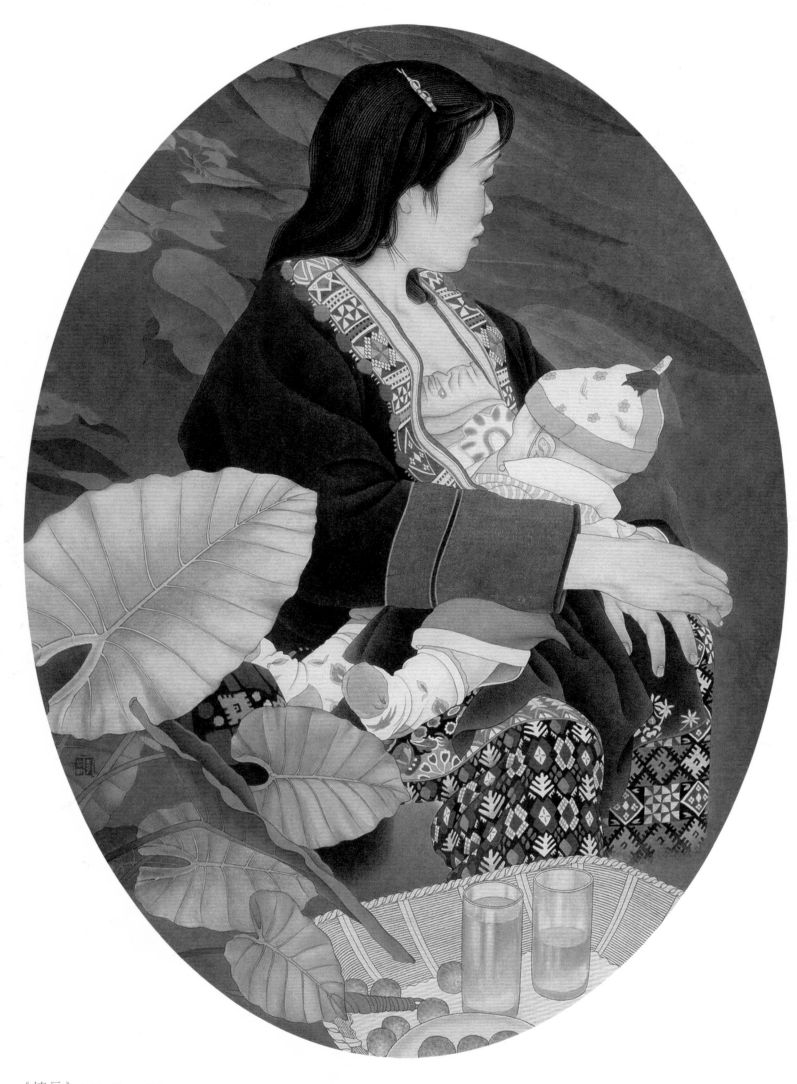

《情長》∣ Feeling of Longing
橢圓69.7x50.5cm　工筆重彩　2004年

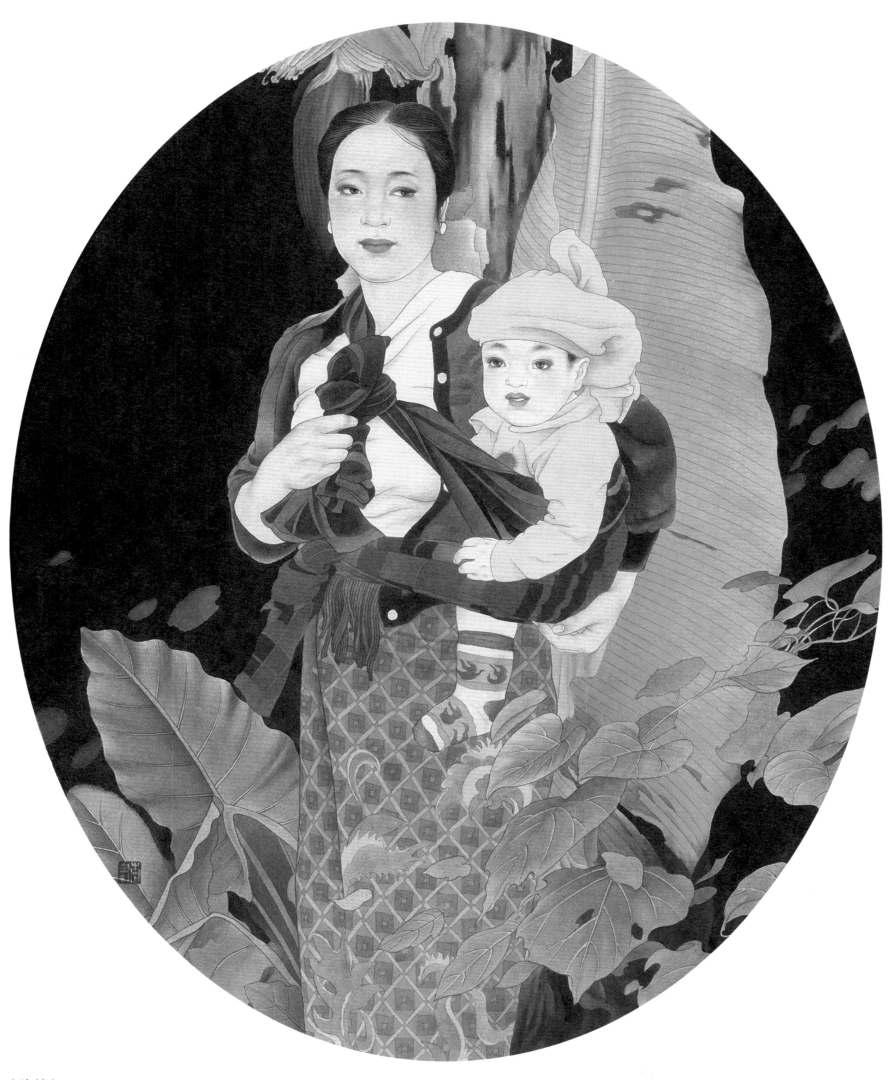

《珍情》I Valued Feeling
椭圆51x40.8cm　工笔重彩　2005年

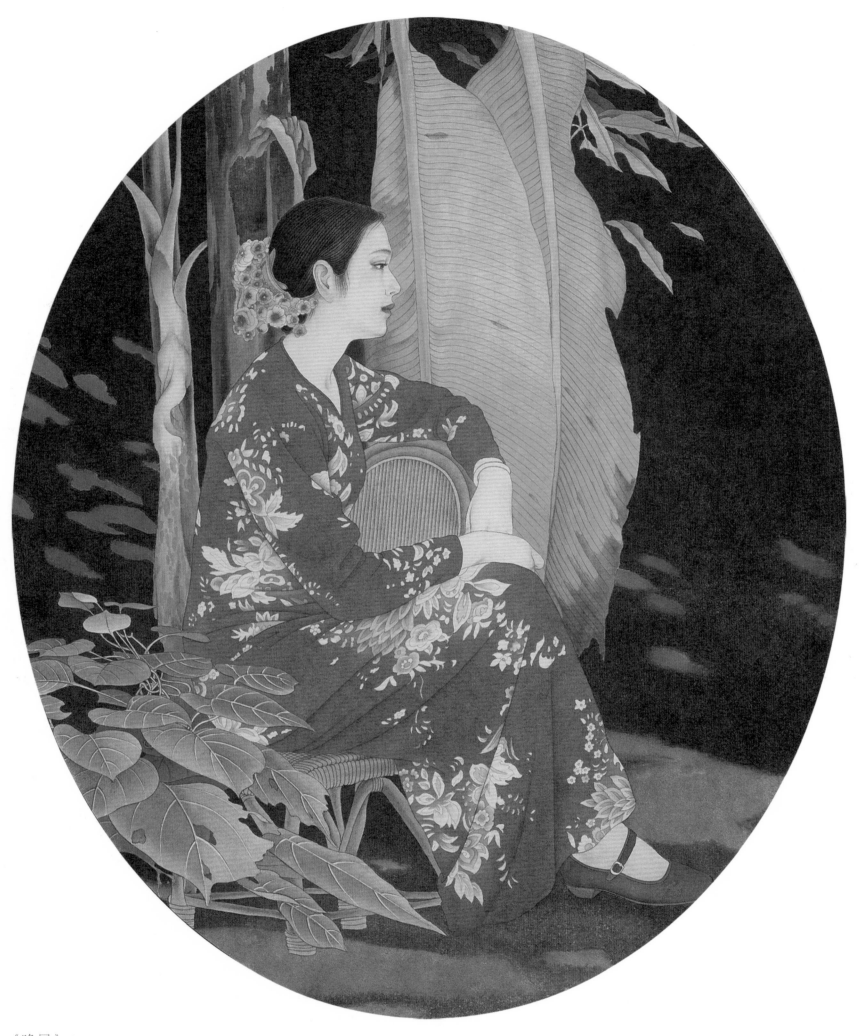

《晚風》1 Evening Wind
橢圓50.8x40.9cm 工筆重彩 2004年

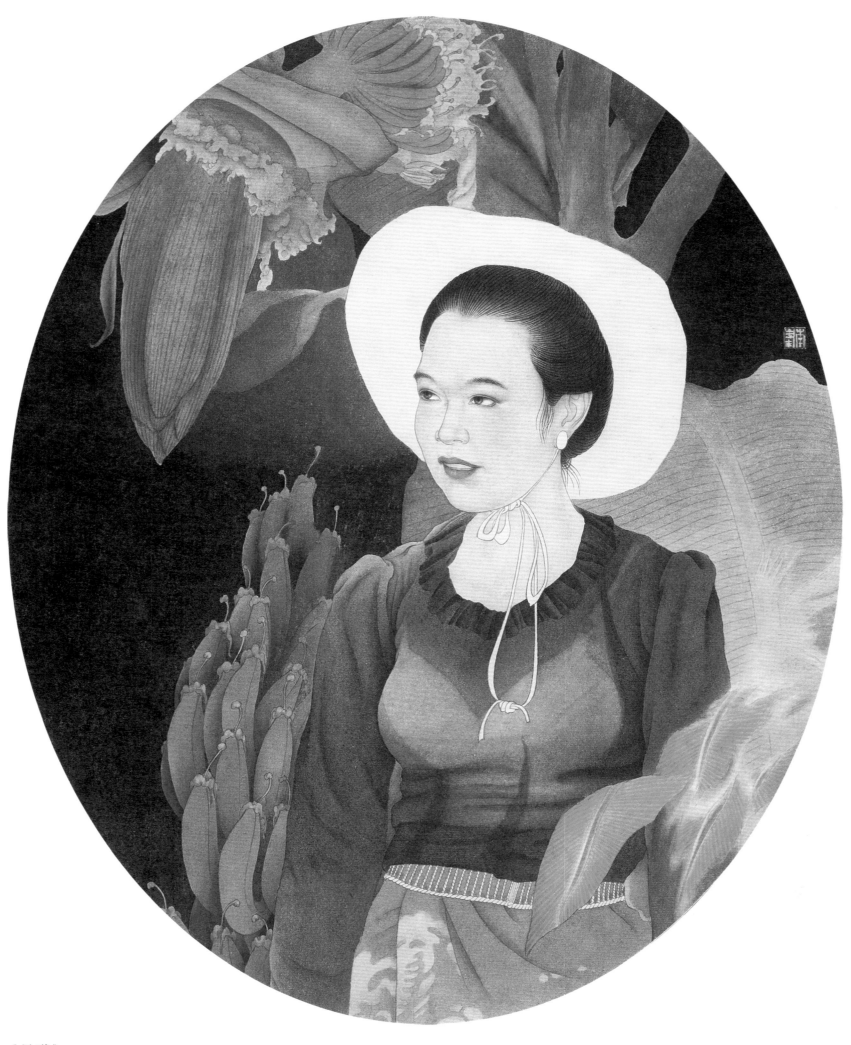

《晨曦》| Early Dawn
椭圆51x40.8cm　工笔重彩　2005年

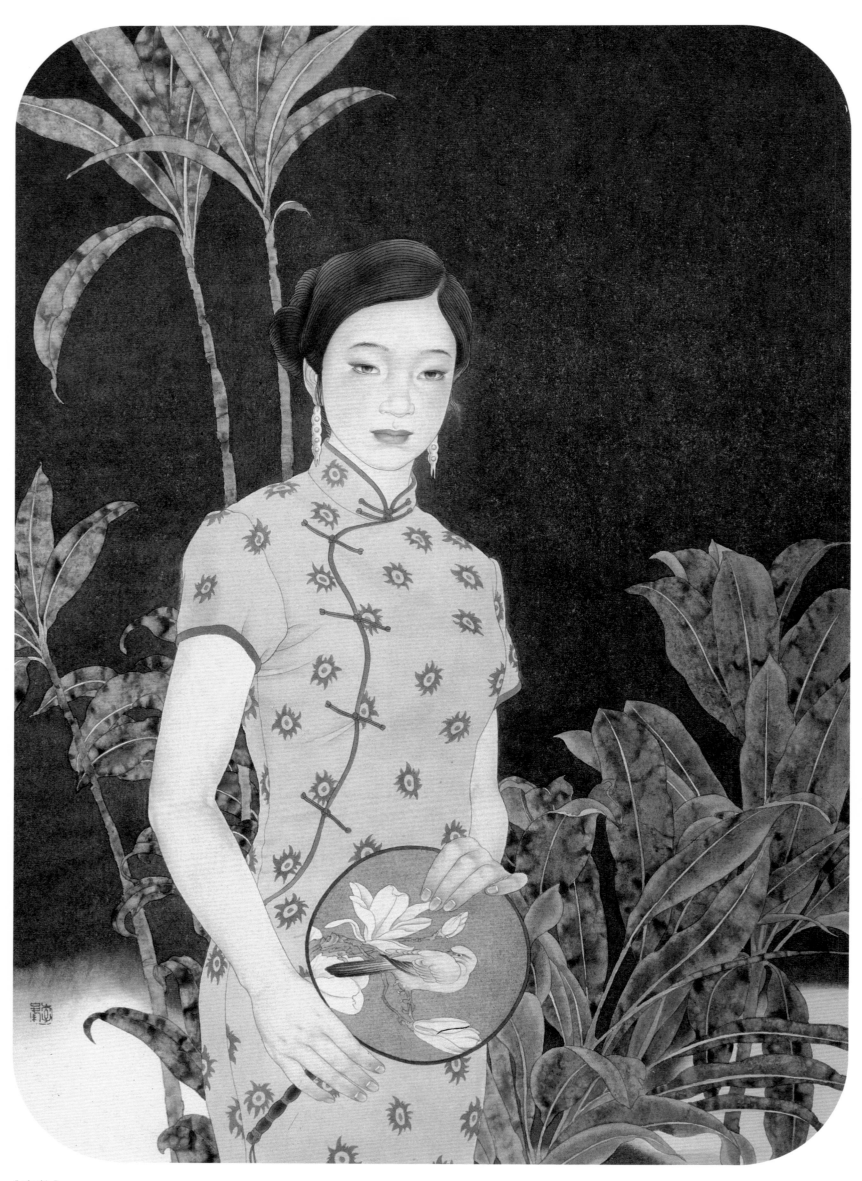

《幽韵》| Tranquil Harmony
70.3x50cm 工筆重彩 2005年

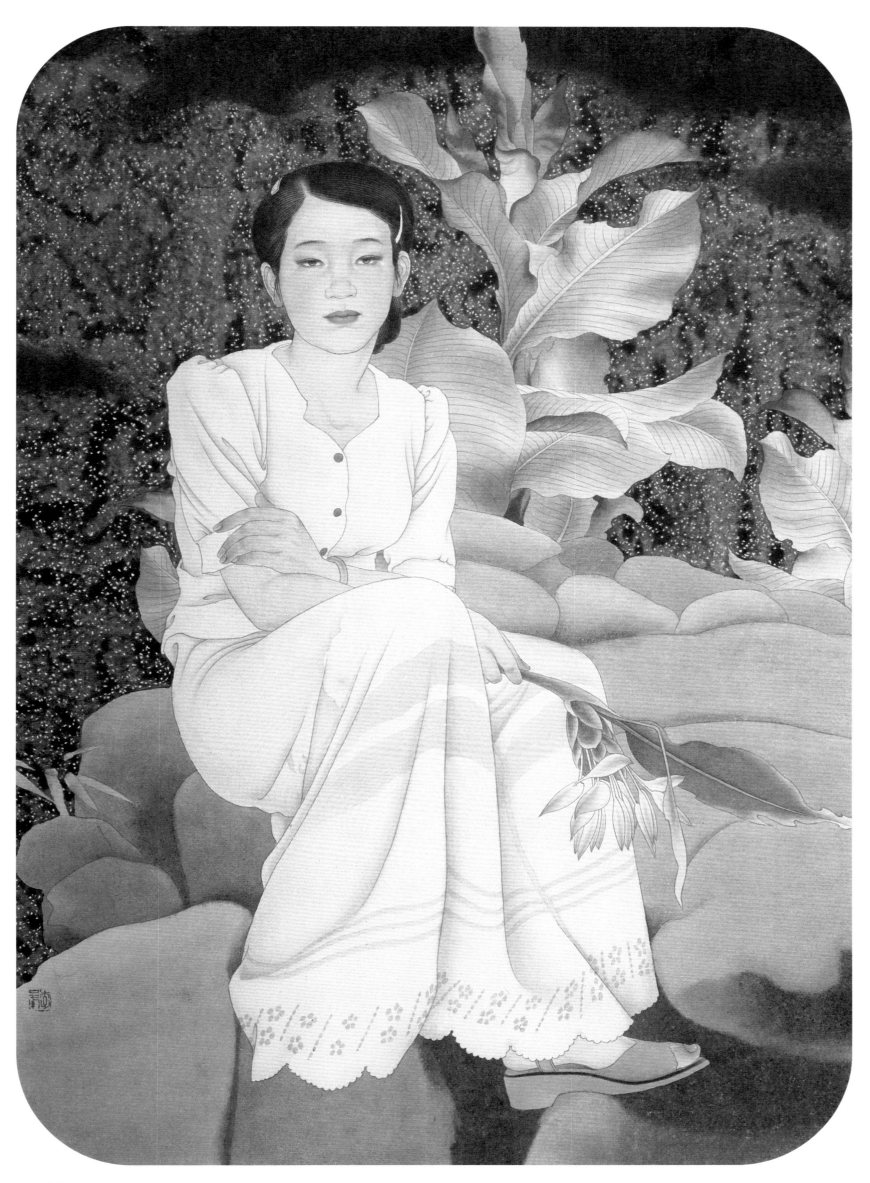

《心曲》I Song of the Heart
70.3x50cm　工筆重彩　2005年

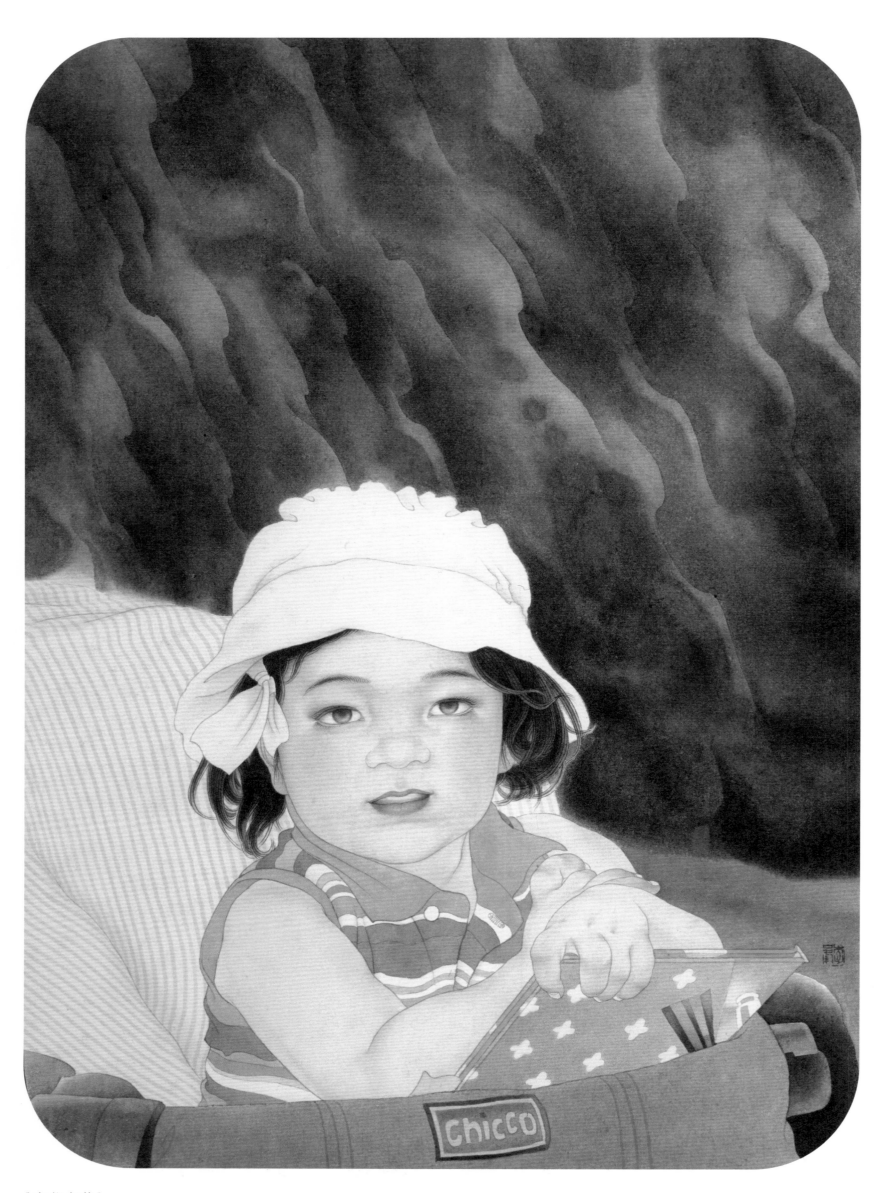

《幽谷之夢》｜ Valley Dream
70.3x50cm 工筆重彩 2005年

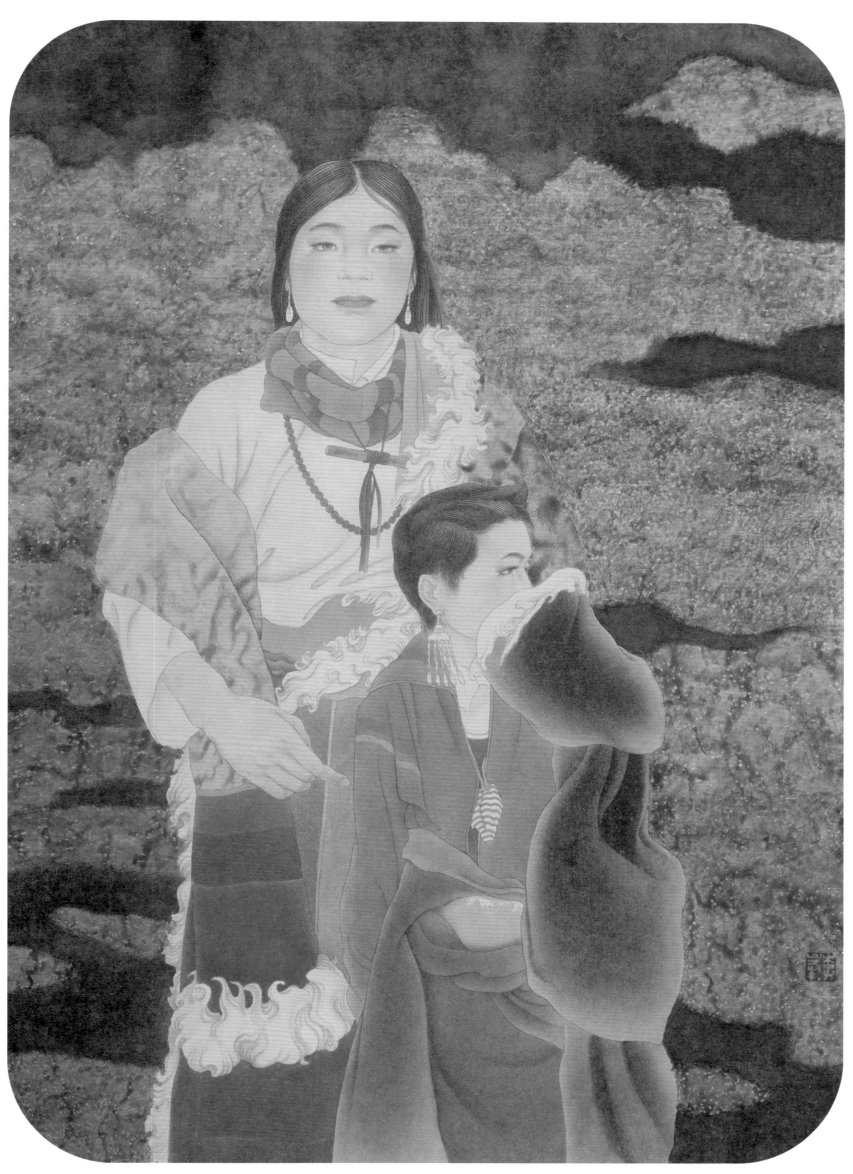

《遠山》∣ Distant Mountain
70.3x50cm　工筆重彩　2005年

《美人斛》| Beautiful Wine Container
58.2x57.5cm 工筆重彩 2003年

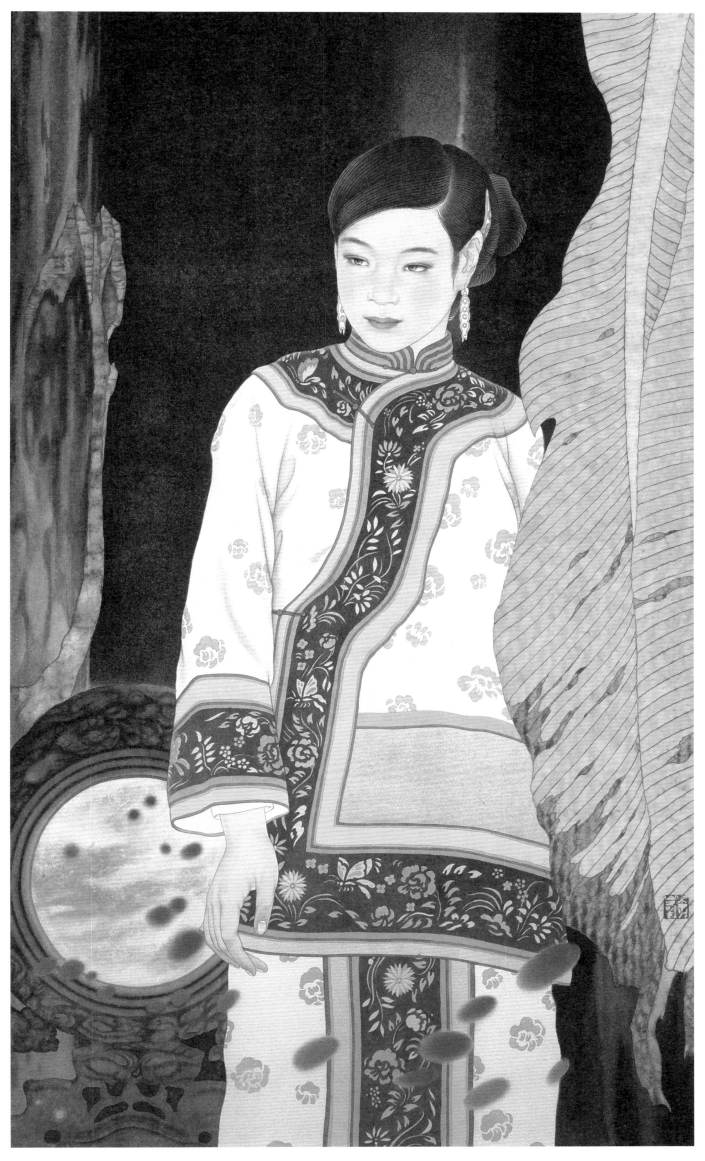

《月光》 I Moon Light
70.3x50cm　工筆重彩　2005年

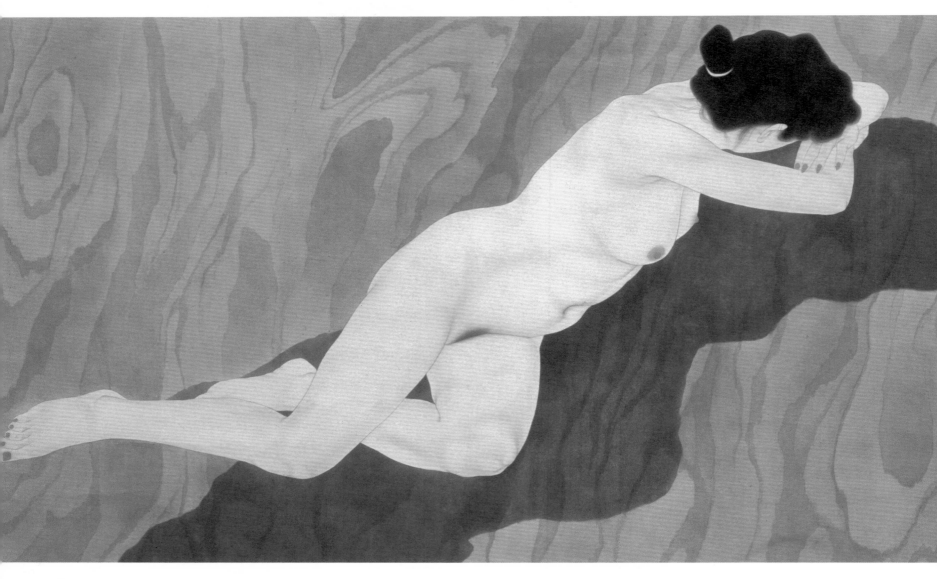

《夢》I Dream
120x60cm　工筆重彩　1989年

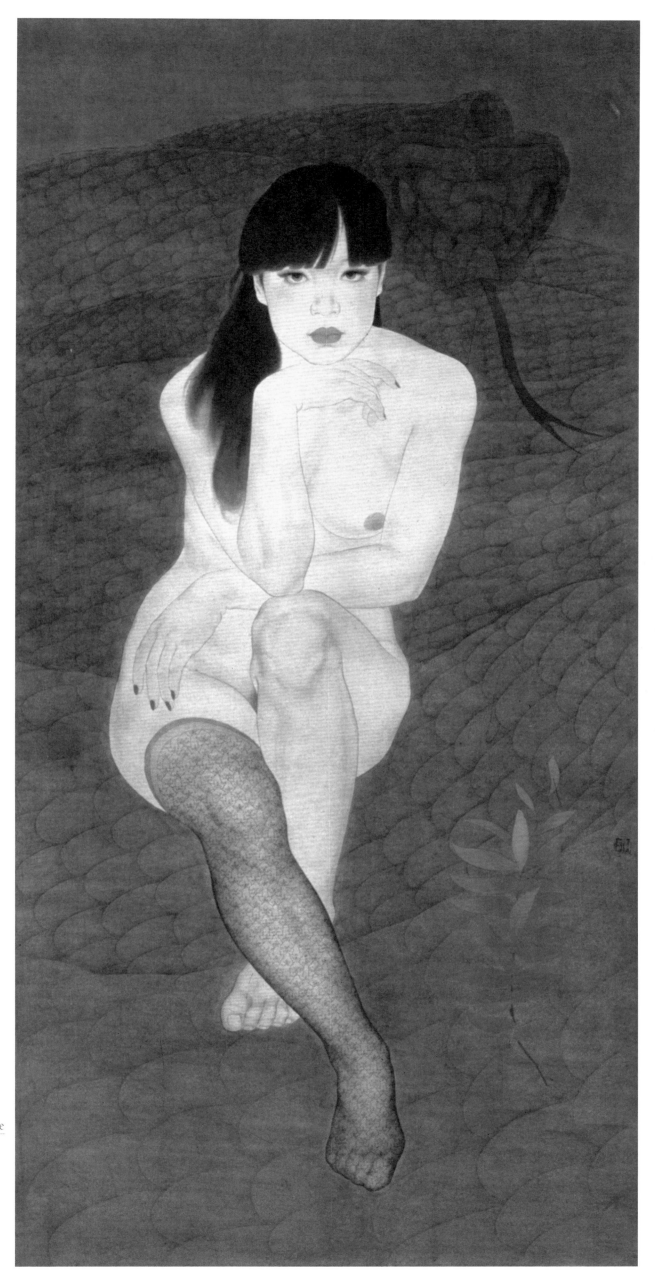

《少女與蛇》 | Teenage Girl and Snake
110x55cm 工筆重彩 1989年

《少女》| Teenage Girls
110x60cm
工筆重彩
1989年

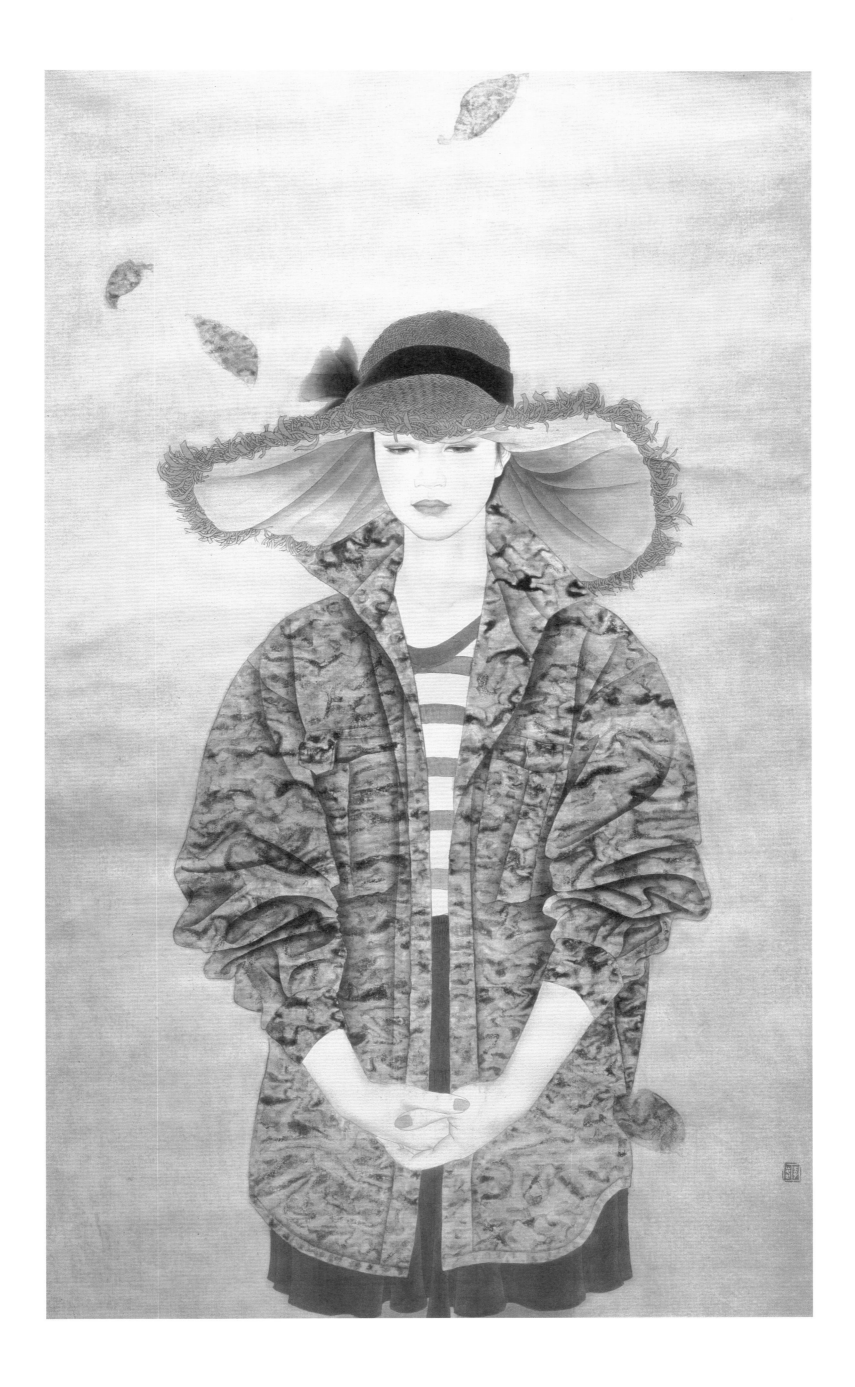

《雪》I Snow
II2.3x59.8cm
工筆重彩
I989年

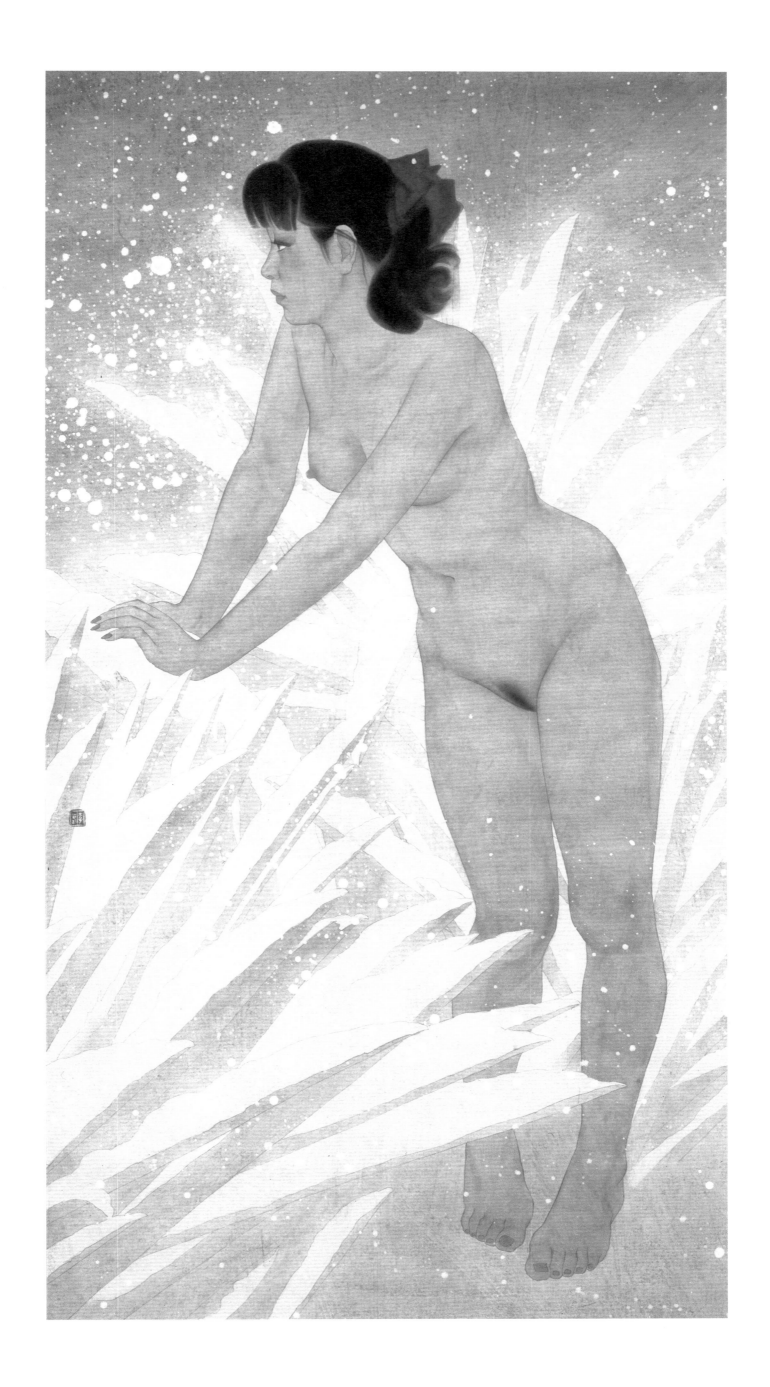

CHRONOLOGY

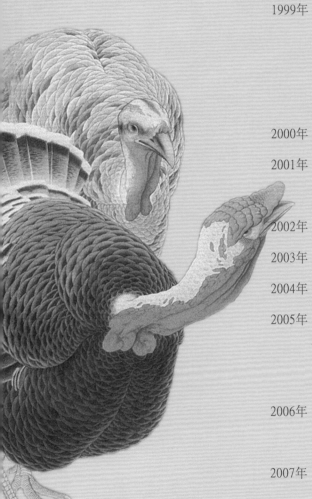

李峰，1959年生於武漢；1991年湖北美術學院研究生畢業，獲碩士學位。現為湖北美術學院中國畫系主任、教授、碩士研究生導師，中國美術家協會會員，湖北省美術家協會中國畫藝委會主任。湖北省有突出貢獻中青年專家，獲第五屆湖北省文藝明星獎。中國美術館、深圳美術館、深圳南山現代美術館等場館以及歐洲、美國、日本、韓國、中國大陸、臺灣等地區均有其作品收藏。

1984年	《圍牆》參加 "第六屆全國美展"。
1989年	《桃花源記》獲"第七屆湖北省美展"銅獎。
1991年	臺灣《兒童日報》出版《屈原》（精裝工筆連環畫集）。
1992年	《留蔭》獲紀念"在延安文藝座談會上的講話"發表五十周年湖北省美展優秀獎。
1993年	湖北少兒美術出版社出版《少兒看圖讀笑話》（工筆插圖集）。
1994年	《心原》為"第八屆全國美展優秀作品展"獲獎作品並獲"第八屆湖北省美展"銀獎中國美術館收藏。
1997年	《遠芳》參加"全國中國人物畫展覽"。《苗山故事》（合作）參加"全國首屆中國畫邀請展"
1998年	《香蕉園》獲"第四屆中國工筆畫大展"銀獎。
1999年	《南風》獲"第九屆全國美展獲獎作品展"優秀獎並獲"第九屆湖北省美展"銀獎。《我的畫》獲"共慶澳門回歸祖國--中國藝術大展" 優秀獎（北京.澳門）。參加文化部組織的"中國藝術名家澳門寫生團"。參加"'99中青年工筆畫家作品提名展"（深圳美術館）。參加"99'深圳市穀風畫院美術作品邀請展"。出版《李峰國畫作品精選》（人民美術出版社）。
2000年	出版《現代工筆人物表現特技》（遼寧美術出版社）。赴日本藝術考察並參加"日中友好交流展"。
2001年	《家》獲"慶祝建黨八十周年全國美展"優秀獎並獲"慶祝建黨八十周年湖北省美展" 金獎。出版《中國當代畫家自選輯--李峰》（湖北美術出版社）。
2002年	出版《中國畫仕女畫法》（廣西美術出版社）。
2003年	《母子》獲"湖北省小幅中國畫作品展"學術獎。
2004年	《心語》獲"首屆美術文獻提名展" 提名獎。
2005年	出版《中國畫構圖法則》（廣西美術出版社）。出版《工筆人物課堂教程》（天津美術出版社）。參加《中國當代人物畫壇名家作品展》（煙臺美術博物館）。參加《學院工筆.首屆全國青年工筆肖像藝術展》（北京今日美術館）。
2006年	《穿越時代的優雅.李峰個展》（臺北沁德居藝廊）。參加《面孔.中國製造》展覽（澳大利亞.悉尼）。參加《都市言情當代水墨畫展》（武漢博物館.北京可創銘佳藝苑）。
2007年	參加《湖北當代國畫優秀作品展》（北京.全國政協禮堂）。 參加《湖北中青年中國畫家作品聯展》（深圳何香凝美術館）。 赴韓國藝術考察並參加《第3回韓中美術交流展》（韓國大丘文化藝術會館）。 參加《學院.經典--全國美術院校工筆畫名家作品邀請展》（武漢.北京）。 參加《第四屆全國畫院優秀作品展覽》（湖北藝術館）。 參加《湖北省五十周年美術作品展》（武漢）。
2008年	參加《筆墨春華2008中國畫作品邀請展》（湖北藝術館）。 參加《10力中國畫小品邀請展》（武漢四海點睛藝術會所）。 臺北沁德居藝廊出版《李峰畫集》。

Born in Wuhan in 1959, Li Feng received his master's degree in art in 1991. He is now Chairman of the Chinese Painting Department at Hubei Fine Art College, a full time professor and a master's study class moderator. He is also a member of the Chinese Fine Art Association, and Chairman of the Chinese Painting Committee of the Hubei Fine Art Association. He has made outstanding contributions as a young middle-aged expert of Hubei Province, and is considered the 5th cultural star of Hubei Province. His works have been collected widely by collectors from Europe, American, Japan, China, Taiwan etc. They are displayed at the Chinese Fine Art Museum, the Shenzhen Museum, Shenzhen Nan Shan Modern Art Museum and so forth.

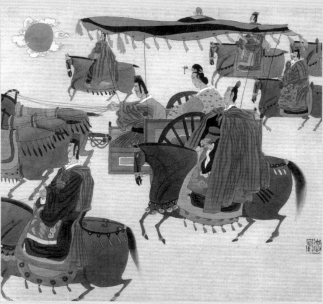

《三十六計-1》 Thirty-Six Stratagems-1
27.8x26.1cm 工筆重彩 1992年

1984	"Fence Wall" was entered in the 6th National Art Exhibition.
1989	"Peach Flower Spring Diary" won the Brass medal at the 7th Hubei Art Exhibition.
1991	A special edition of his fine stroke comic collection "Chue Yuen" was published by the Children's Daily paper in Taiwan.
1992	"Letting the Shadow Stay" won the Excellence prize at the Hubei Art Exhibition's 50th anniversary commemorating the "Yen-An Literature/Cultural Panel Discussion."
1993	"Children Seeing the Illustrations and Reading the Jokes" (a fine stroke illustration) was published by Hubei Children's Fine Art Publisher.
1994	"Land in my Heart" won the Excellence prize at the 8th National Art Exhibition and the Silver Medal at the 8th Hubei Province Art Exhibition; it was collected by the Chinese Art Museum.
1997	"Fragrance from Afar" joined the National Chinese Portrait Painting Exhibition; "Story of Miau Mountain" was entered in the first National Chinese Invitation Exhibition.
1998	"Banana Orchard" won the Silver Medal at the 4th Fine Stroke Chinese Painting Grand Exhibition.
1999	"South Wind" won the Excellence prize at the 9th National Art Exhibition and the Silver Medal at the 9th Hubei Province Art Exhibition. "My Painting" won the Excellence prize at the Chinese Art Grand Exhibition in celebration of Macau's return to the Motherland (Beijing, Macau) He joined the Chinese well-known artist landscape sketching group of the Cultural Bureau Organization, and entered the young middle-aged fine stroke painter nomination exhibition (Shenzhen Art Museum) as well as the Ku-Fong College Art Work invitational exhibition in Shenzhen City. The Li-Feng Chinese Painting Fine Collection was published by People's Art Publisher.
2000	His "The Special Impress Technique of Modern Fine Stoke Portraits" was published by Liau-Ning Art Publisher; he went to Japan on an art study tour and was part of the Japanese and Chinese Friendship Exchange Exhibition.
2001	"Home" won the Excellence prize at the National Art Exhibition of the 80th anniversary celebrating the Nation's Founding and the Gold Medal at Hubei Province Art Exhibition of the 80th Anniversary of the Nation's Founding. The "Chinese Contemporary Self-Collection-Li Feng" was published by Hubei Fine Art Publisher.
2002	His "Chinese Painting Portraying Beautiful Women Techniques" was published by Kuang-Si Fine Art Publisher.
2003	"Mother and Son" won the Academic Prize at the small size Chinese Painting Exhibition of Hubei Province.
2004	He participated in the 1st Art Documentary Nominated Exhibition.
2005	His "Composition Structure Principles for Chinese Painting" was published by Kuang-Si Fine Art Publisher and his "Class Teaching Process of Fine Stroke Portraits" was published by Tienjing Fine Art Publisher. He joined the Chinese Art Circle of Well-known Contemporary Portrait Painters Work Exhibition held by Yen-Tai Art Museum and joined "The Academic Fine Stroke, 1st National Youth Fine Stroke Portrait Art Exhibition" held by Beijing Today Art Museum.
2006	The "Excellent Elegance that Transcends the Ages" Li-Feng Solo Exhibition was held by Taipei Chinderjyu Art Gallery. He joined the "Faces--Made in China" Exhibition in Sydney, Australia and joined the "City-Talking-Feeling Contemporary Water-Ink Painting Exhibition" at Wuhan Museum and Beijing Creation Art Gallery.
2007	He joined the "Hubei Province Contemporary Chinese Painting Excellent Work Exhibition- at Beijing National Politician Committee Hall and joined the "Hubei Middle Youth Chinese Painting Painter United Exhibition of Shenzhen He-Tsiang-Ning Art Museum. He also went to Korea on the Art Study Tour of the 3rd Korean-Chinese Art Exchange Exhibition (Korean Daegu Culture Art Institute) and joined the Academic Classic- the 1st National Art College Fine Stroke Painting well-known Painter Invitation Exhibition" of Wuhan, Beijing. He then joined "The 4th National Painting Institute Excellent Work Show-at Hubei Art Museum, and joined " the Hubei Province 50th Anniversary Fine Art Work Show-Wuhan.
2008	He joined" the Brush-Ink Spring Flower 2008 Chinese Painting Work Invitation Exhibition"- Hubei Art Museum, and the " Ten-Power Chinese Painting Invitation Show- at the Wuhan Painting the Eyes of the Four Seas Art Gathering. The Art Album of Li-Feng will be published by Taipei, Chinderjyu Art Gallery.

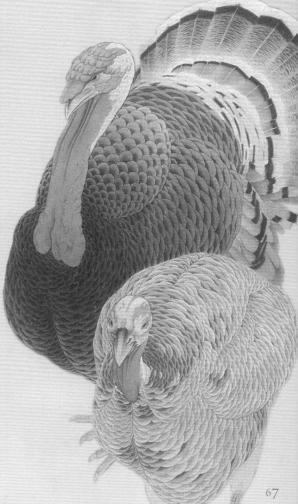

李峰畫集

A COLLECTION OF LI FENG'S PAINTINGS

發 行 人 / 李淑芳　DIRECTOR / LISA LEE

設　　計 / 楊哲鈞　ART DESIGNER / YANG CHE CHUN

攝　　影 / 林茂榮　PHOTOGRAPHER / LIN MAO JUNG

翻　　譯 / 祁夫潤　TRANSLATOR / JEROME F.KEATING

出 版 社 / 沁德居藝廊　PUBLISHER / CHIN DER JYU GALLERY

出版地址 / 台灣台北市大安區信義路四段199巷14號　ADDRESS / 14,LANE 199,SEC.4,SHIN YI ROAD ,TAIPEI TAIWAN

電　　話 / 886-2-27074086　TEL / 886-2-27074086

傳　　真 / 886-2-27059768　FAX / 886-2-27059768

電子信箱 / chinderjyu@ethome.com.tw　E-MAIL / chinderjyu@ethome.com.tw

印　　刷 / 宏騏印刷有限公司　PRINTER / HONG-CHYI PRINTING CO.

峻揚紙業有限公司　JIUNN YANG PAPER CO., LTD.

印　　數 / 500本　PRINTING SUM / 500.

出版日期 / 2008年5月　PUBLICATION DATE / 2008.5

定　　價 / 新台幣800元整　PRICE / NT$.800

ISBN / 978-957-28185-6-5 (精裝)